VISUAL EXPLORER GUIDE
VENICE

VISUAL EXPLORER GUIDE
VENICE

ANGELINA VILLA-CLARKE

amber
BOOKS

First published in 2025

Copyright © 2025 Amber Books Ltd

All rights reserved. No part of this publication may be reproduced, stored in a retrieval system, or transmitted in any form or by any means, electronic, mechanical, photocopying, recording, or otherwise, without prior written permission of the copyright holder.

Published by
Amber Books Ltd
United House
North Road
London
N7 9DP
United Kingdom
www.amberbooks.co.uk
Facebook: amberbooks
YouTube: amberbooksltd
Instagram: amberbooksltd
X(Twitter): @amberbooks

Project Editor: Anna Brownbridge
Designer: Mark Batley
Picture Research: Adam Gnych

Printed in China

Contents

Introduction	6
Cannaregio	8
Castello	30
Dorsoduro	52
San Marco	88
San Polo	136
Santa Croce	168
Outer Islands	192
PICTURE CREDITS	224

Introduction

Is it a cliché to say that there is nowhere else in the world like Venice? Maybe, but it's true. Found on Italy's northeastern coastline and spread across 118 islands, arriving in this city that floats on water is like stepping foot into the pages of a Baroque fairy tale. Built from the mudflats of a desolate lagoon some 1500 years ago, it has risen to become one of the most majestic – and fragile – man-made destinations on Earth.

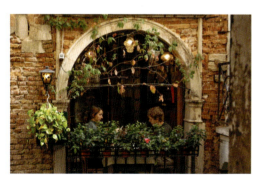

So famous are many of its sights that, even for a first-time visitor, it can feel strangely familiar. Yet, Venice is also a place of mystery and intrigue; where footsteps echo at night on lonely passageways, where nondescript buildings open up to reveal fascinating treasures and where you travel on waterways rather than on roads.

Venice is a city of light and dark, of sunshine and shadows. The lapping of water is a constant soundtrack. Visit in the summer and watch a beam of sunlight strike a gilded cupola; in the winter, eerie mists bring about a sense of melancholy that simply enhances the city's splendour. Yes, there is surely no other place like Venice.

ABOVE:
Venice: the most romantic city in the world?
RIGHT:
The city still holds masked balls, which take place during Carnevale di Venezia.

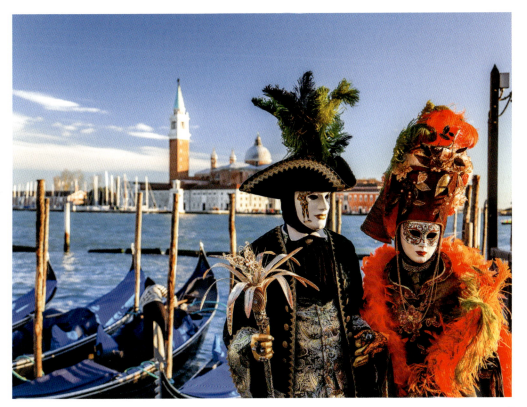

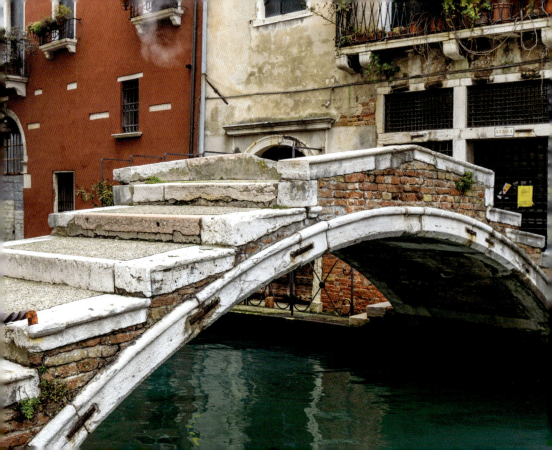

Cannaregio

The most northerly of Venice's six districts – known as *sestieri* – Cannaregio is perhaps one of the most authentic areas of the city. Without the hoards of tourists that are found elsewhere, this is where you'll come across everyday Venetian life – where locals shoot the breeze in tiny bars and children play in parks, a rarity in this dense city.

For those who have not wholly embraced the art of 'getting lost' in Venice's labyrinthine streets, called *calli*, Cannaregio will offer some respite. Despite being home to Calle Varisco, at 53cm (20 in) wide, the narrowest *calle* in Venice, it boasts wide avenues, or *fondamenti*, making this one of the easiest districts to navigate.

Cannaregio is perhaps best known for its Jewish quarter, one of the oldest 'ghettoes' in the world dating back to 1516 and made famous in Shakespeare's *Merchant of Venice*. At the time, the Jewish population was forced to live in a cramped area that housed the city's foundry, known as *ghèto* in the Venetian dialect. In fact, it is thought that this is where the word 'ghetto' first derived from. Nowadays, it's still a hub for the Jewish population.

A wander around Cannaregio reveals a treasure-trove of Venice's true delights, including some of the city's most beautiful bridges and one of the most impressive supermarkets in Italy. Despar Teatro Italia is carved out of an old theatre – customers shop for food beneath stunning frescoes.

OPPOSITE:
Ponte Chiodo
Crossing the San Felice Canal, Ponte Chiodo is one of two remaining bridges in Venice without parapets or railings. The other is Ponte del Diavolo, found on the island of Torcello.

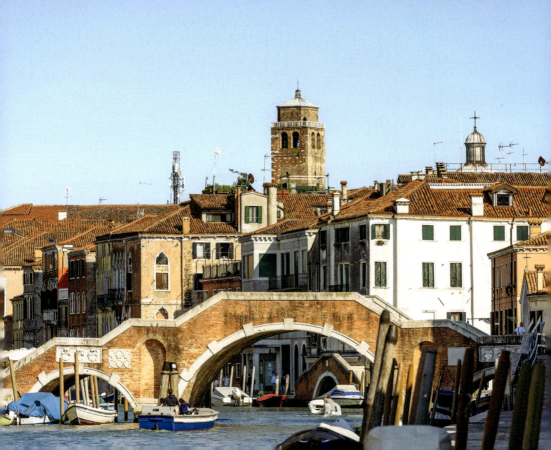

OPPOSITE:
Ponte dei Tre Archi
Considered one of the major bridges in the city, this Baroque-style bridge was built in 1688 and is one of two bridges to cross the Cannaregio Canal. It is the only remaining bridge left in the city with three arches, after which it is named.

RIGHT:
Ponte delle Guglie
The second walkway to cross the Cannaregio Canal, Ponte delle Guglie is also notable for its architecture, due to its dramatic spires at either end, and gargoyles that decorate the arches. It leads into the Venetian Ghetto area and is also close to one of Venice's few green parks.

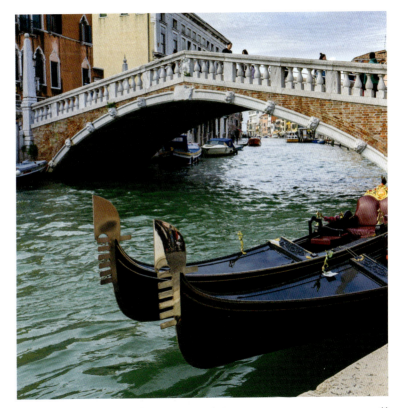

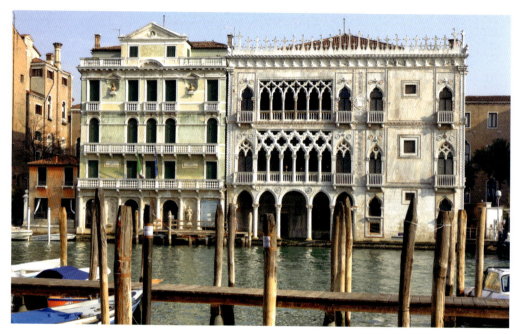

ALL PHOTOGRAPHS:
Ca d'Oro Museum
You can't fail to notice Ca' d'Oro, a magnificent Gothic house, sat on the Grand Canal. One of Venice's most treasured buildings, it was built in the 15th century and once had gold-leaf details on its façade, giving it its name of 'House of Gold'. These have faded, but it still boasts original ogee windows and arched loggias. Remodelled in 1894 by Baron Giorgio Franchetti, it contains works by Titian and Andrea Mantegna.

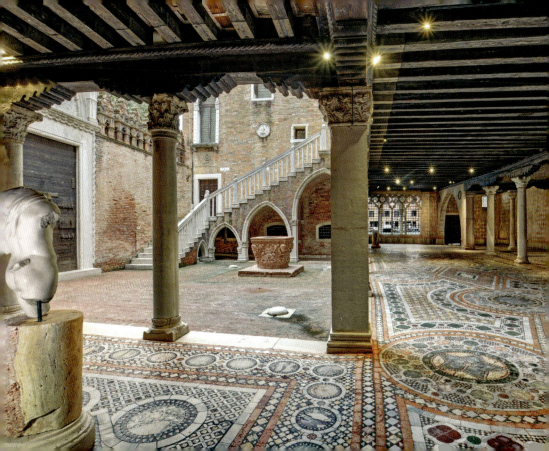

RIGHT:
Chiesa della Madonna Dell'Orto
This late Gothic church, originally constructed in 1350 but rebuilt in the early 15th century, contains works of art by Tintoretto, who was a parishioner and is also buried here alongside his family.

OVERLEAF:
Fondamenta Ormesini
The hub of Cannaregio, this buzzy avenue leads into Fondamenta della Misericordia, where many of the district's local eateries and bars are found. It's also the perfect spot to order an *aperitivo* at the end of the day.

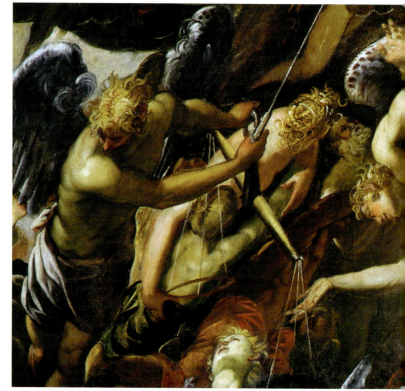

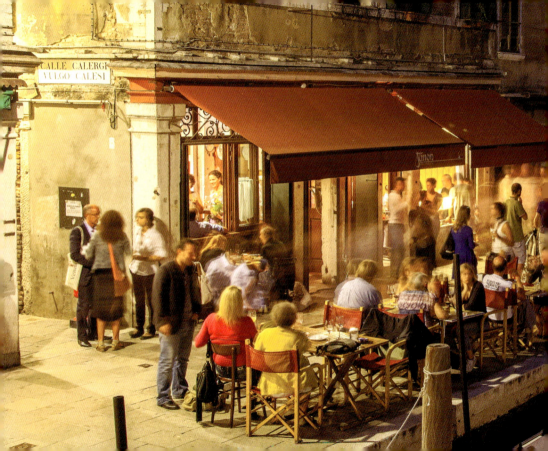

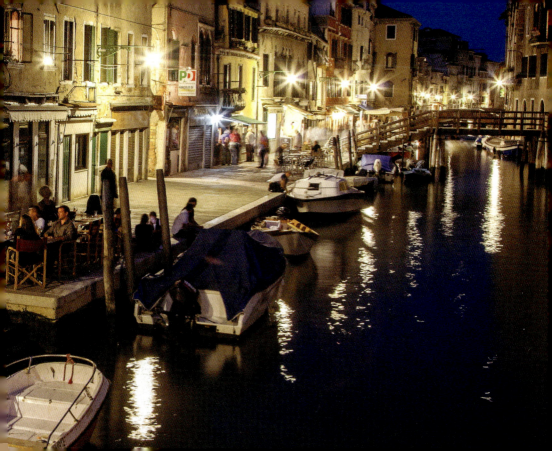

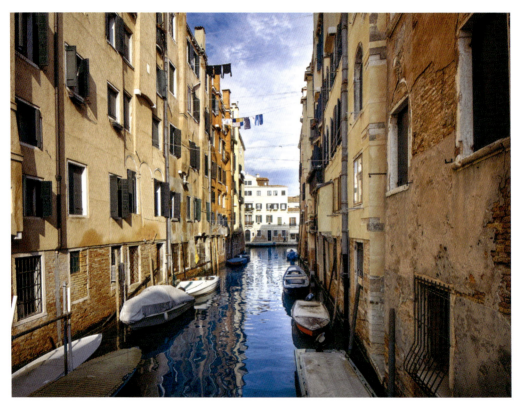

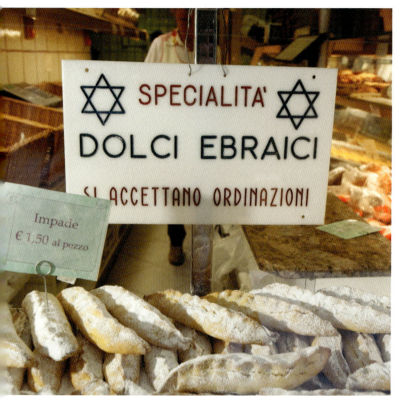

OPPOSITE:
Jewish Ghetto
A small Jewish community still lives in the Ghetto area, where several synagogues can be found. Taller buildings than are typically seen in the rest of Venice can be found here, due to the amount of people that were crammed into such a small area.

LEFT:
Jewish cuisine
Traditional Jewish bakeries sell the Jewish-Venetian specialities *dolci ebraici*, sweet biscuits flavoured with fennel seeds, and *impade* cookies, filled with almond cream.

ALL PHOTOGRAPHS:
Orsoni glass mosaic factory
Dating back to 1880, this historical factory still makes tiny coloured mosaics, known as Venetian *smalti*, using the same techniques as when it was founded. It contains the only furnace allowed to operate with fire in the city. Its Colour Library (far right) houses a vast collection of *smalti* in 3500 colours.

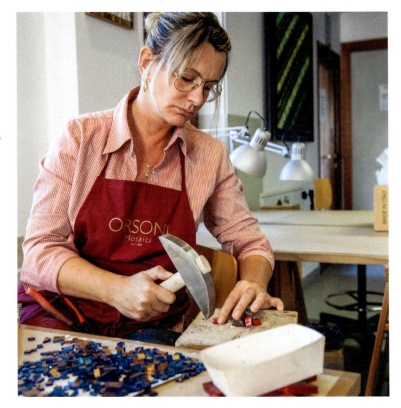

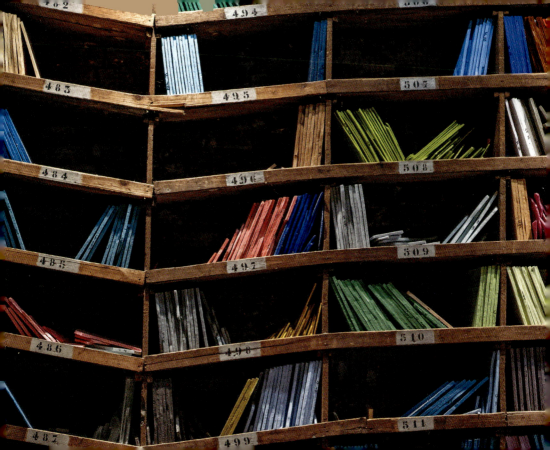

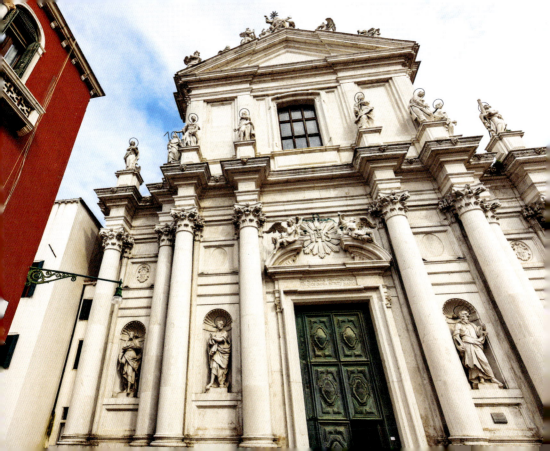

ALL PHOTOGRAPHS:
Chiesa di Santa Maria Assunta
More commonly known as 'I Gesuiti', this Baroque church was built by the Jesuits in 1714. The imposing exterior opens up to reveal an ornate spectacle inside. Walls are covered in green and white patterned marble, sculpted in drapes, to resemble a damask fabric. The church is also home to a Titian masterpiece, the *Martyrdom of St Lawrence*, dating back to 1558.

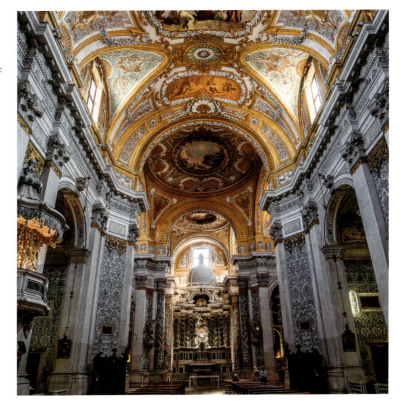

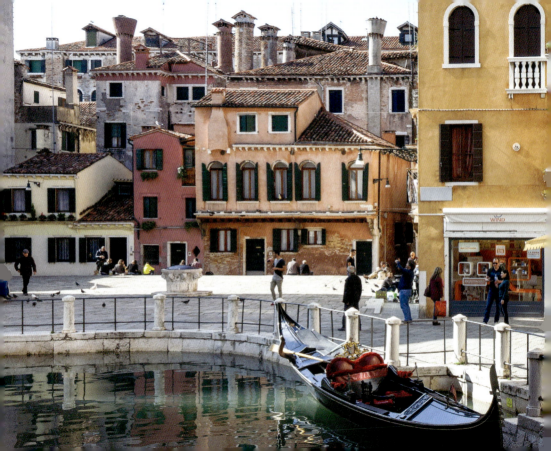

Strada Nuova

This main thoroughfare, connecting the station to the Rialto Bridge, is the longest street in Venice and is often crowded with tourists and locals. If you are looking for a gift to take home, this is the place to come, as it is lined with mask shops, perfumeries and Murano glass stores.

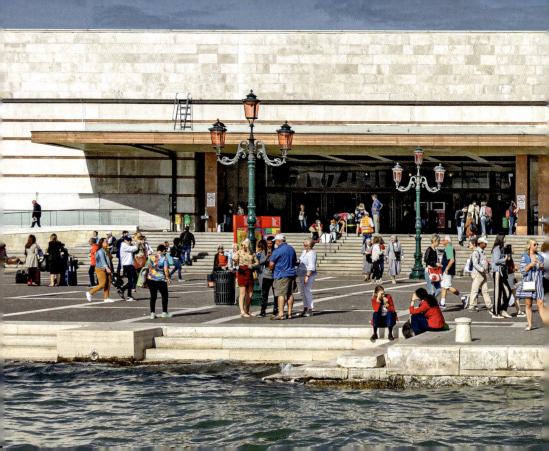

PREVIOUS PAGES:
Santa Lucia train station façade
The clean lines of Venice's main train station are in stark contrast to much of the city's ornate architecture. An example of Modernist design, it was conceived by three different architects, who worked on it from 1924 to 1952.

RIGHT:
Santa Lucia train station
Within minutes after disembarking from your train into Venice, you'll be thrust into a cinematic world of waterways and ancient architecture. No matter how often you visit the city, there seems to be no end to its sense of magical allure.

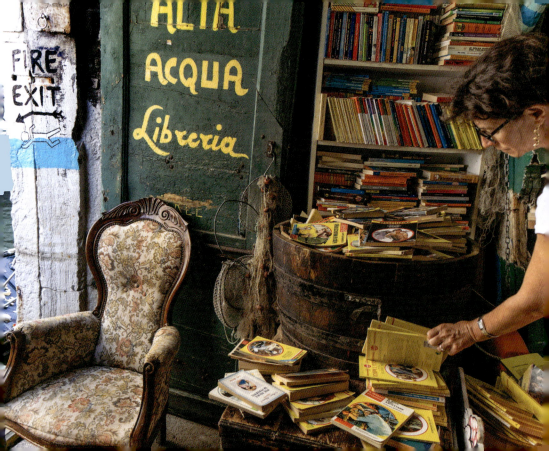

Castello

Found in the east of the city, bordering San Marco and Cannaregio, Castello is the largest of Venice's six *sestieri*. The epicentre of Venice's long history, its name dates from the sixth century when the city's early settlers built a fort on the island of San Pietro. A church, San Pietro di Castello, now stands on this site, rebuilt from where Venice's first cathedral stood from 1451 to 1807.

A wander around the district will bring you across some of the busiest areas of the city *and* some of the quietest. The mighty Arsenale is a sprawling naval shipyard and the heart of Venice's maritime power, founded in the 12th century. Most of the complex is closed to the public, but visitors can get an idea of the superpower that once was at play in the city with a visit to the nearby Museo Storico Navale (Naval History Museum). Via Garibaldi, Venice's widest street, is just the place for a *passeggiata* (a stroll) with its line-up of shops, restaurants and markets, with some vendors selling fish and vegetables straight off their boats, canalside. Along here, Bar Mio is a must for a traditional *tramezzini* (a type of Venetian sandwich), rated among the best in Venice.

For some downtime, head to the Public Gardens, a welcome green space in the city, and home to many exhibitions during the Biennale, the world's largest art gathering held every two years in Venice. Stroll to the far east of Castello and you will reach Sant'Elena, a peaceful residential island, where you will have a snapshot into true Venetian life.

OPPOSITE:
Libreria Acqua Alta
The self-proclaimed 'most beautiful bookshop in the world' should perhaps be renamed 'the most eclectic'. Its ramshackle aesthetic and resident cats all add to its quirkiness.

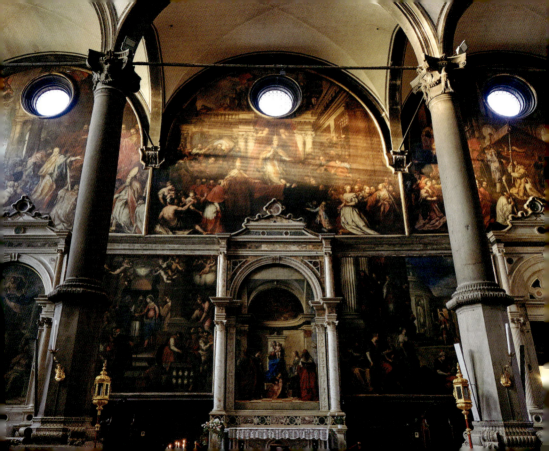

ALL PHOTOGRAPHS:
Chiesa di San Zaccaria
Blending Gothic and Classical Renaissance, this church dates back to the ninth century, and was also originally home to a convent which became famous for the lax behaviour of the resident aristocratic-girls-turned-nuns. Its walls are lined with art. A highlight is Giovanni Bellini's *Madonna and Child with Saints* (1505, left). The tombs of several doges (the original rulers of Venice) lie in the eerie, waterlogged crypt (below).

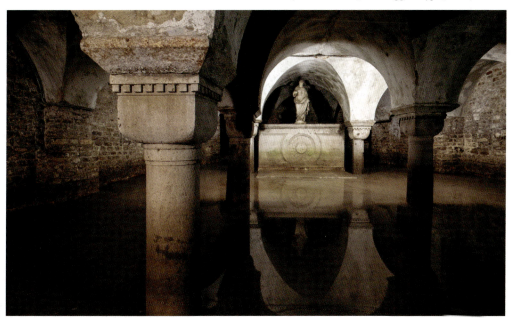

ABOVE:
Chiesa di San Giorgio dei Greci
Recognisable from its leaning campanile (bell tower), this Greek Orthodox church dates back to 1530 and contains the original women's gallery and a wall of gilded icons.

OPPOSITE:
Chiesa di Santa Maria Formosa
Found in an atmospheric market square, the church is home to one of Venice's masterpieces: Palma il Vecchio's polyptych, *St Barbara and Saints* (1523).

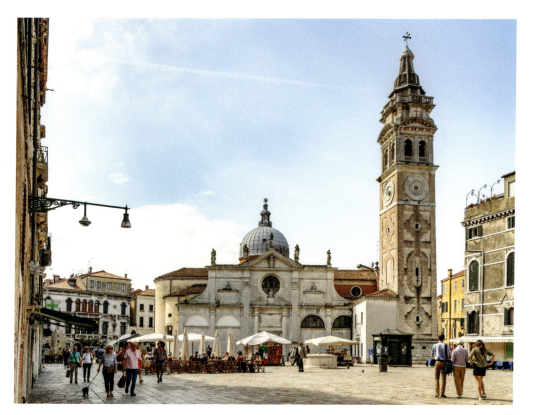

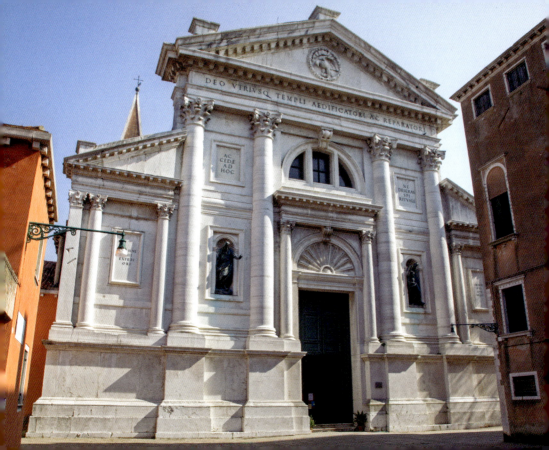

OPPOSITE & RIGHT:
Chiesa san Francesco della Vigna
Built on what was once a vineyard (*vigna*) in the 13th century, this is one of just two Franciscan churches in Venice. Famous due to its façade by Andrea Palladio and its freestanding campanile, rebuilt in the 16th century and modelled after the one in St Mark's Square. It also contains many notable works of art, such as frescoes by Battista Franco and Bellini's *Madonna and Saints* (1507). The chapel (right) was designed by Tommaso Temanza, with fine marble reliefs and a magnificent fresco by Giovanni Antonio Pellegrini.

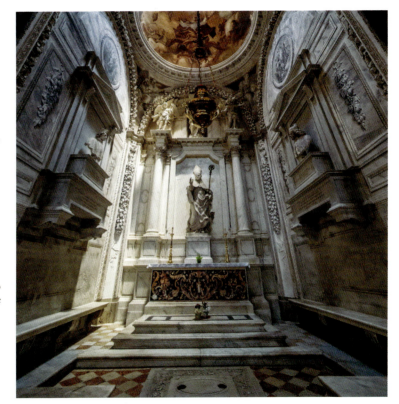

Naval History Museum
Found close to the Arsenale, this museum, carved out of an old warehouse, shows the fascinating history of the Venetian navy from 1860 to today, with models of vessels from the 17th century, uniforms and battleships.

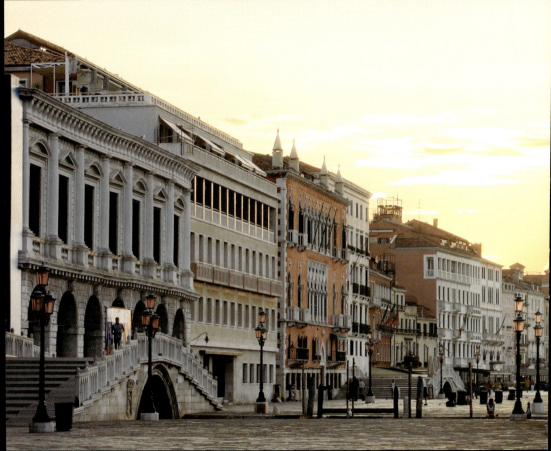

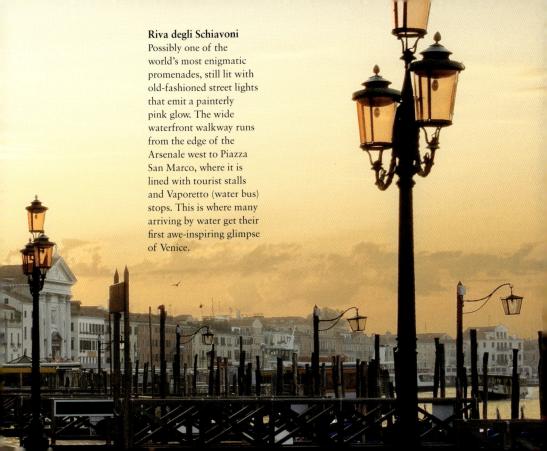

Riva degli Schiavoni
Possibly one of the world's most enigmatic promenades, still lit with old-fashioned street lights that emit a painterly pink glow. The wide waterfront walkway runs from the edge of the Arsenale west to Piazza San Marco, where it is lined with tourist stalls and Vaporetto (water bus) stops. This is where many arriving by water get their first awe-inspiring glimpse of Venice.

Gondolas

Riva degli Schiavoni is also home to many gondola ranks. The hand-built wooden boat was once the city's main mode of transport. It's still the most elegant way to see Venice by water but, be warned: it's also the most expensive.

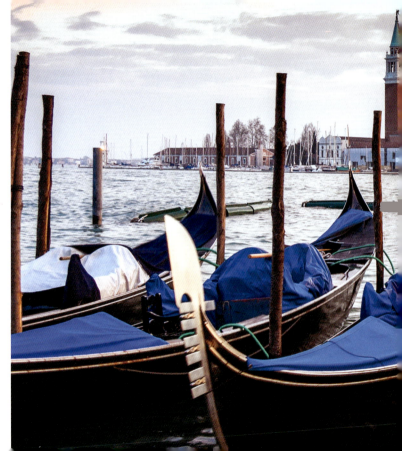

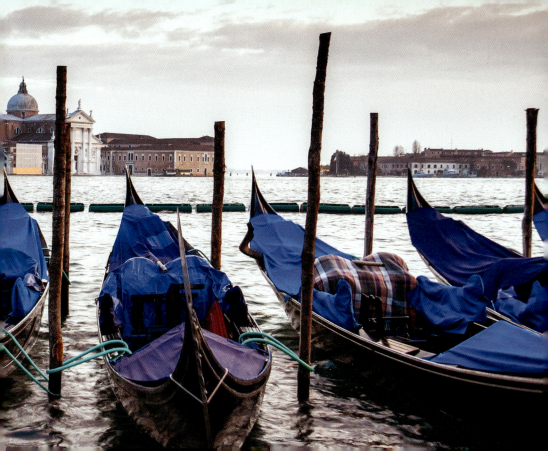

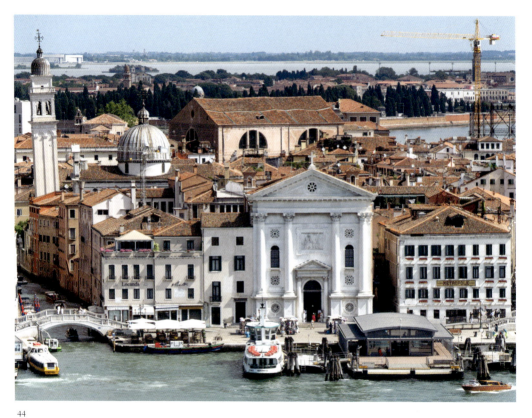

RIGHT & PREVIOUS PAGES:
Chiesa di Santa Maria della Pietà
Known simply as La Pietà, the church is found on Riva degli Schiavoni, and has a famous acoustic-friendly oval interior. In the 18th century, the composer Antonio Vivaldi was the church's choirmaster and it became known for its stellar musical performances. To this day, it still remains a popular venue for classical music concerts.

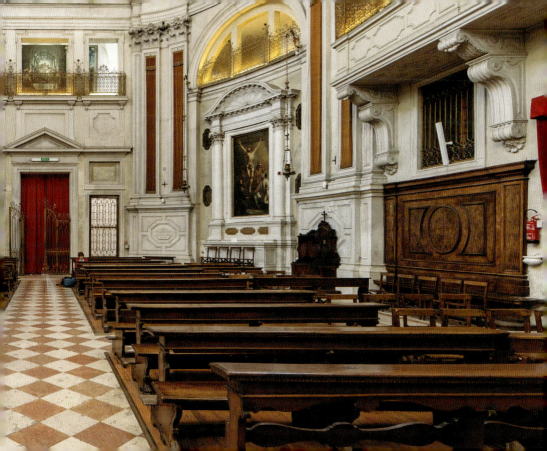

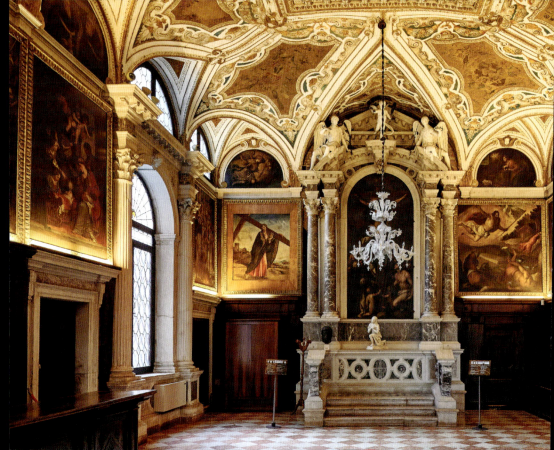

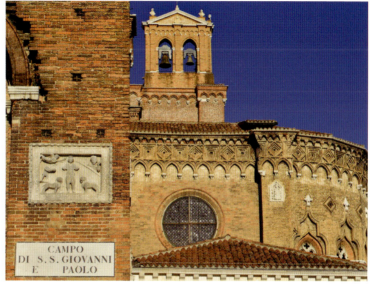

OPPOSITE & ABOVE:
Chiesa di Santi Giovanni e Paolo
This celebrated Gothic church is also known as San Zanipolo, the Pantheon of Venice. Built by the Dominicans in the 14th century, it has a brick façade (above right) and is home to tombs of 25 doges, as well as multiple artworks by Venetian masters.

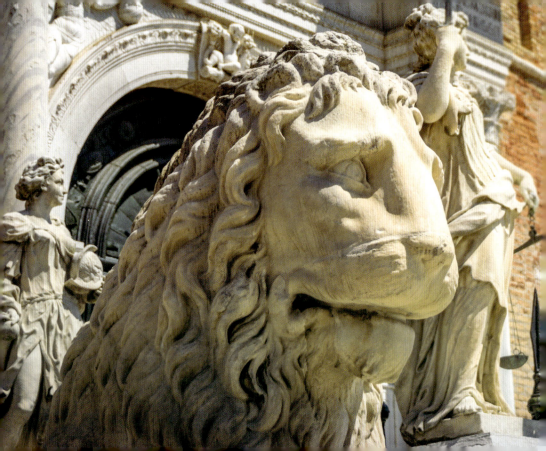

ALL PHOTOGRAPHS:
The Arsenale
The word 'Arsenale' derives from the Arabic word for 'house of industry', and by the 16th century, this 'city within a city' had some 16,000 workers to construct ships for the Venetian navy and multiple shipping companies. Two stone lions guard the entrance, and, although it is closed to the public (aside from the Biennale), visitors can get a view of it from the bridge at Campo Arsenale.

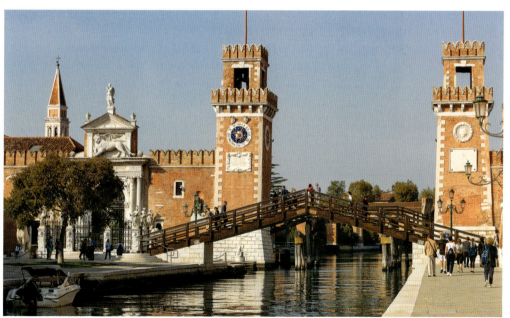

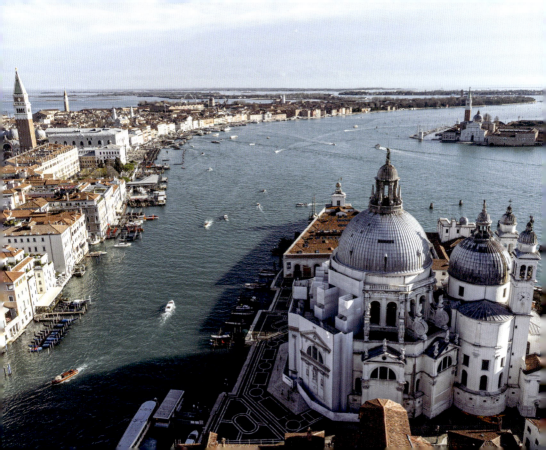

Dorsoduro

To soak up the best of Venice – when it comes to its dazzling art and imposing architectural landmarks – then, head to Dorsoduro. Found on the opposite side of the Grand Canal to San Marco, it attracts fewer tourists than the city's famous square and has just as many treasures. Its world-class galleries, such as the Gallerie dell'Accademia and the Peggy Guggenheim Collection, are bursting with iconic pieces of art. The Baroque masterpiece that is the church of Santa Maria della Salute, dominating Dorsoduro's tip, is one of the most recognisable monuments in Venice.

Dorsoduro's name, meaning 'hard back', refers to the relatively solid foundations of the district compared to the mud flats found elsewhere in the city, where the inhabitants could put down roots.

Consequently, many Venetians chose to live in this area and there is still is a high concentration of merchants' houses and palazzi found here.

To the south, the district overlooks the wide and picturesque Giudecca Canal as well as the large island of Giudecca. The Zattere, a broad walkway that runs along the canal, is still where many Venetians will take their evening stroll or enjoy an al fresco meal. Its spaciousness gives a breathing space away from Venice's usual narrow *calli*.

Dorsoduro is also home to the city's university and, undoubtedly, the reason why it is known as the most artsy and bohemian of Venice's *sestieri*. Consequently, there are plenty of authentic bars, osterias and artisan shops, especially around the buzzy Campo Santa Margherita.

OPPOSITE:
Basilica di Santa Maria della Salute
Known simply as the 'Salute', meaning 'health', it took 50 years to build the church that was commissioned to mark the end of the great plague. Every 21 November, a procession still takes place to mark the occasion.

OPPOSITE:
Basilica di Santa Maria della Salute
The church was completed in 1681 and it contains a number of Titian masterpieces, as well as Luca Giordano's *Presentation of Mary at the Temple* (1674). The Neapolitan artist painted three canvases for the church.

RIGHT:
Ca'Rezzonico
Not to be missed, this marble-fronted palazzo museum is one of the most opulent in Venice and is full of stunning salons full of 18th century artefacts. It also boasts four frescoes painted by Tiepolo. In 1887, it was bought by the poet Robert Browning who died in the palace in 1889.

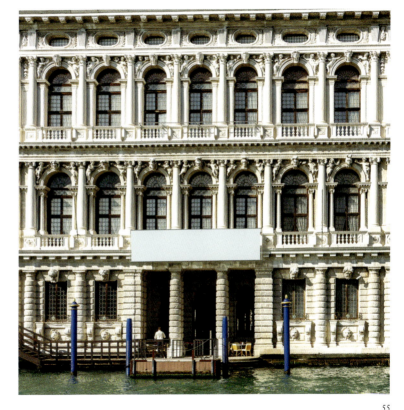

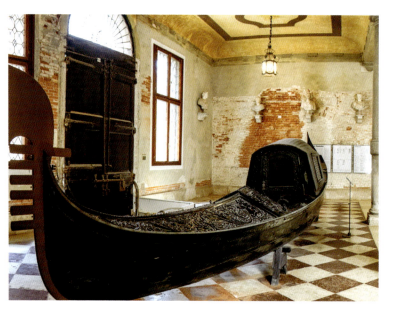

ALL PHOTOGRAPHS:
Inside Ca'Rezzonico
As well as one of the oldest surviving gondolas (above), known as 'Laura', dating from the early 1900s, one of the highlights of Ca'Rezzonico is the gilded, first-floor ballroom (right). It is resplendent with fantastical frescoes by artists Giambattista Crosato and Mengozzi Colonna.

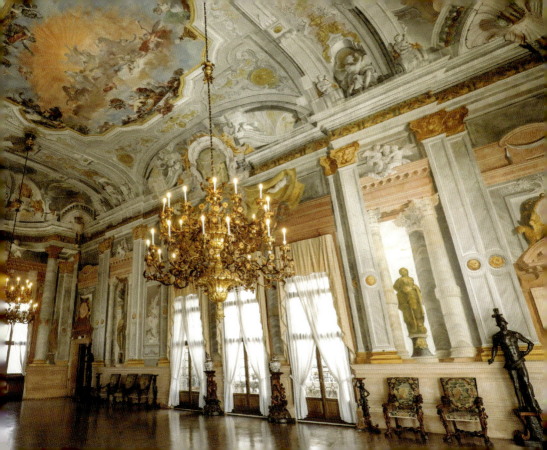

Gallerie dell'Accademia
The museum is filled with an overwhelming collection of masterpieces, spanning the Byzantine to Rococo eras, including the vast canvas that is *The Presentation of the Virgin in the Temple* (1534–1538) by Titian.

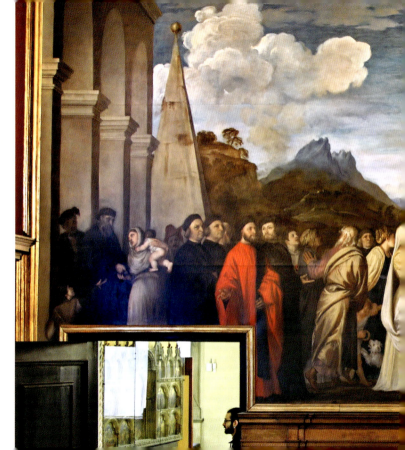

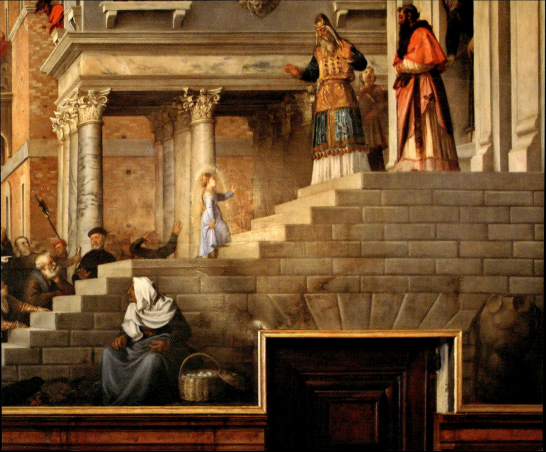

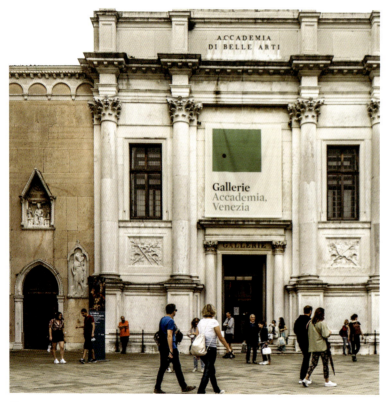

LEFT:

Gallerie dell'Accademia

The Accademia houses the largest collection of Venetian art in the world, including works by Tintoretto, Tiepolo and Veronese. Founded in 1750, it was boosted in 1807 by Napoleon, whose troops looted some of the city's best pieces from churches and monasteries that he had suppressed.

OPPOSITE:

Peggy Guggenheim Collection

The palazzo was owned by millionairess and patron of the arts Peggy Guggenheim, who stipulated that her vast collection of art should remain in Venice after her death.

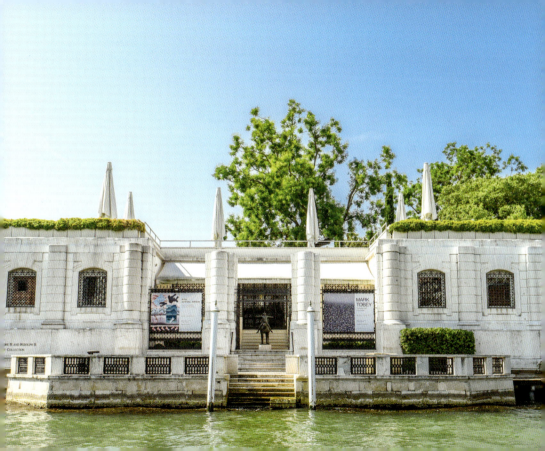

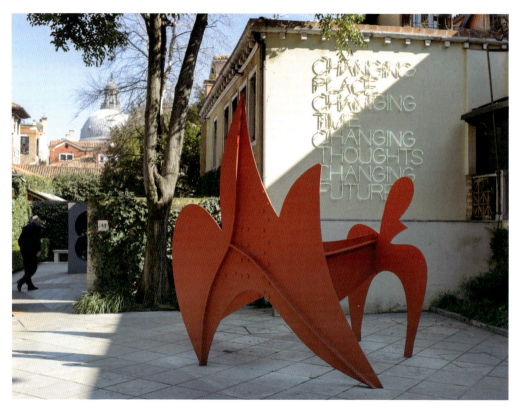

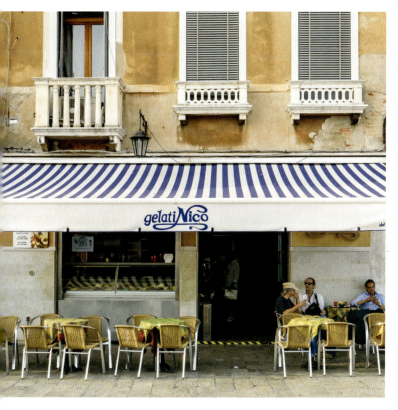

OPPOSITE:
Peggy Guggenheim Collection
One of Europe's leading modern art galleries, the Peggy Guggenheim Collection, features art from the 20th century onwards, including pieces by Pablo Picasso, Salvador Dalí, René Magritte and Paul Klee.

LEFT:
Gelati Nico
Founded in 1937, this waterside gelateria, found on the Zattere, serves some of the best ice cream in Venice and is perfect for people-watching. Ask for the house special, the 'Gianduiotto', which features Gianduja hazelnut chocolate and whipped cream.

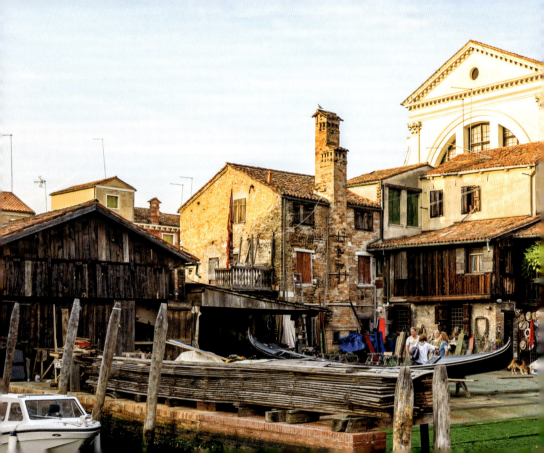

Squero di San Trovaso

Found near Zattere, the Squero (or workshop) of San Trovaso dates back to the 17th century, and is one of the last gondola shipyards remaining in Venice. Visitors can book guided tours.

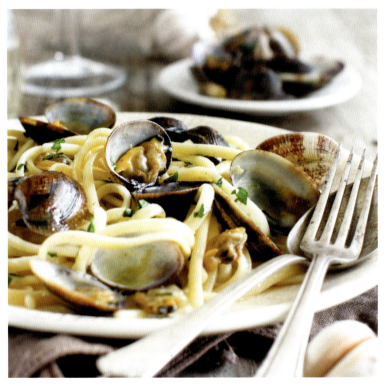

Venetian cuisine
Dorsoduro is home to some of Venice's most authentic restaurants, many of which are found on Calle Lunga San Barnaba (along the canal, Rio di San Barbara, are many floating market stalls, too). Found close by, Trattoria Donna Onesta (right), found adjacent to the bridge of the same name, specialises in seafood, such as spaghetti alle vongole (pictured left).

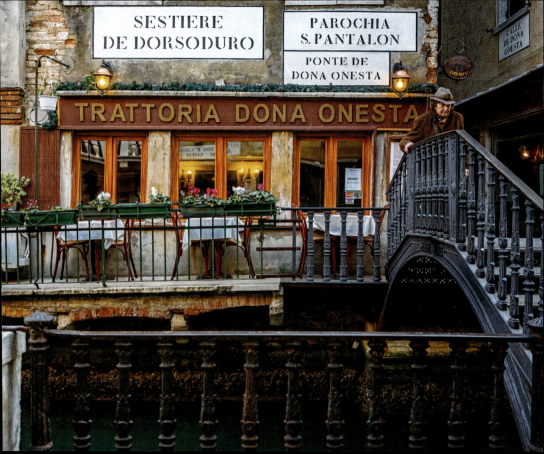

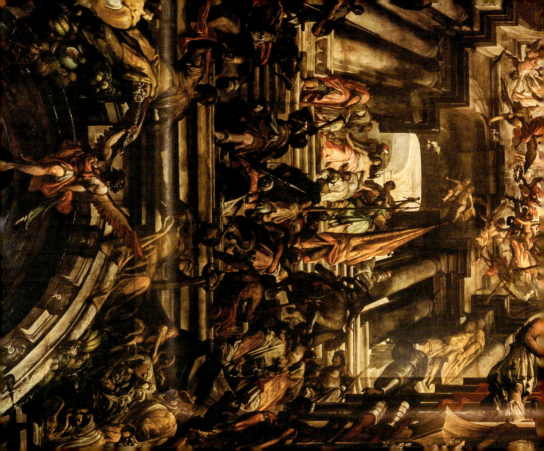

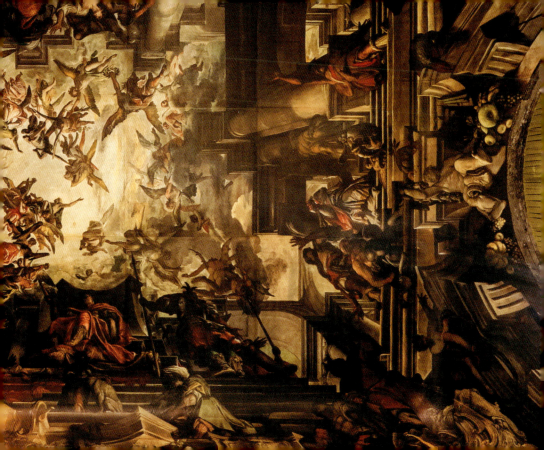

PREVIOUS PAGES:
Chiesa di San Pantalon
San Pantalon Church was founded in the ninth century. Its spectacular ceiling features the biggest oil painting in the world: *Martyrdom and Apotheosis of St Pantalon*, by Giovanni Antonio Fumiani (1680–1704).

RIGHT:
Seafood
Many Venetian dishes feature fish and seafood, such as cuttlefish and clams. Fried calamari is a typical street food, with some restaurants serving the dish in a paper cone.

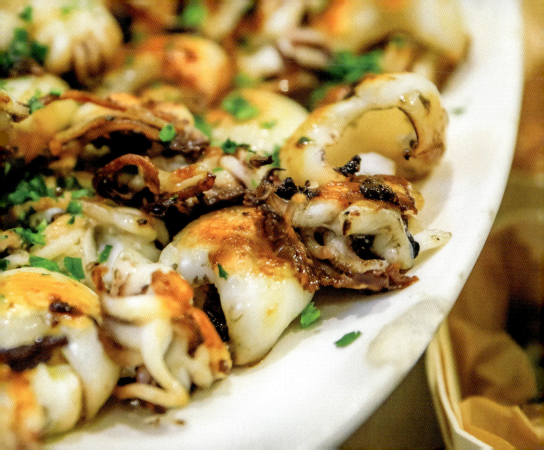

OPPOSITE:
View from Casa dei Tre Occhi, Giudecca
Found on La Giudecca, the striking building, with its three large windows – to maximise the light inside for the artist to work – overlooks the Giudecca Canal, giving some of the best views across to San Marco.

BELOW:
Fondamenta delle Zitelle, Giudecca
The Casa dei Tre Occhi is found near the church of Zitelle and features distinctive patterned brickwork.

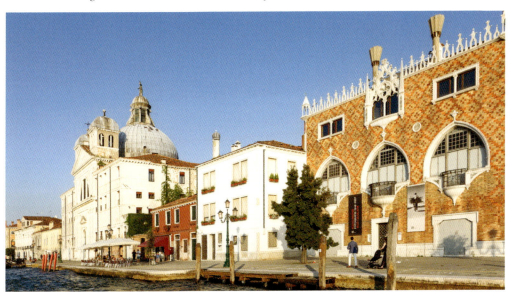

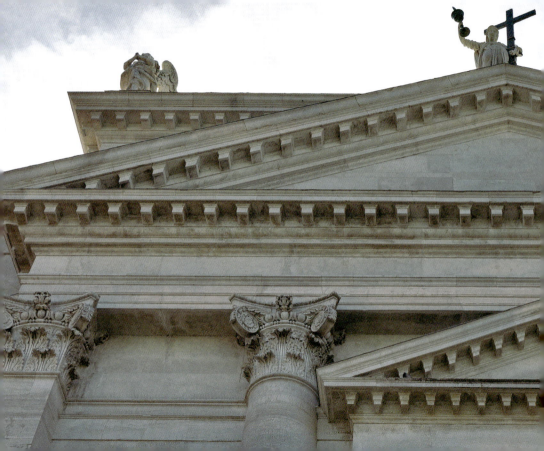

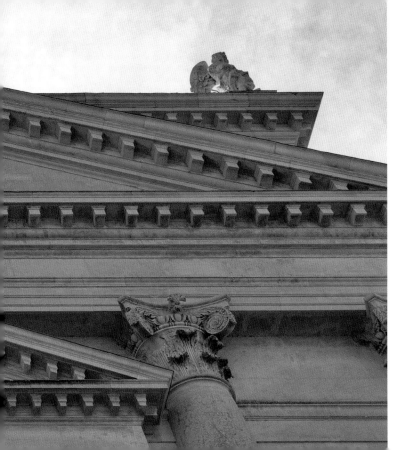

Il Redentore, Giudecca

Designed by Palladio in 1577, the church of 'The Redeemer' was built in thanksgiving for the deliverance of the city after the outbreak of plague in 1575.

ALL PHOTOGRAPHS:
Il Redentore, Giudecca
La Giudecca's distinguished church is an example of Andrea Palladio's most sophisticated design, inspired by the ancient architecture of Rome. Each year, in July, the Feast of the Redeemer Festival is held in thanksgiving. A bridge of boats is made across the Giudecca Canal, with thousands crossing to visit the church, as they have done for hundreds of years.

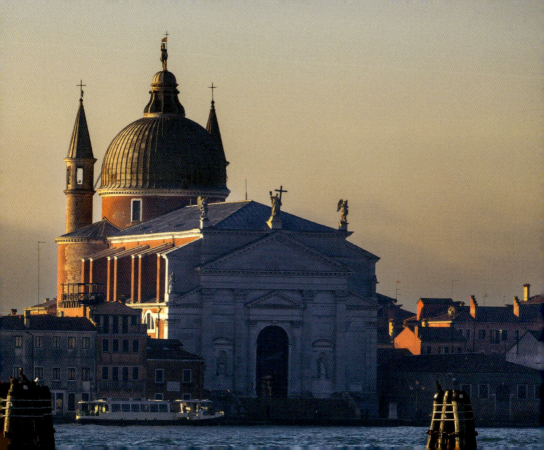

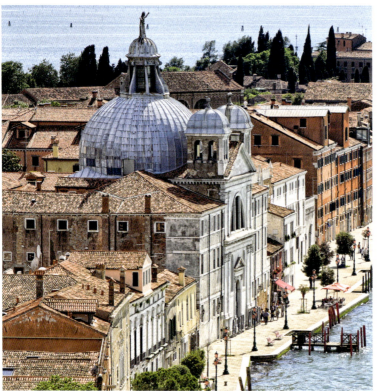

LEFT:

View of Fondamenta delle Zitelle, Giudecca
A bird's eye view along the wide avenue that is Fondamenta delle Zitelle, taken from San Giorgio Maggiore's bell tower.

RIGHT:

A quiet canal on La Giudecca
Many streets on La Giudecca are residential and take you off the 'beaten track'.

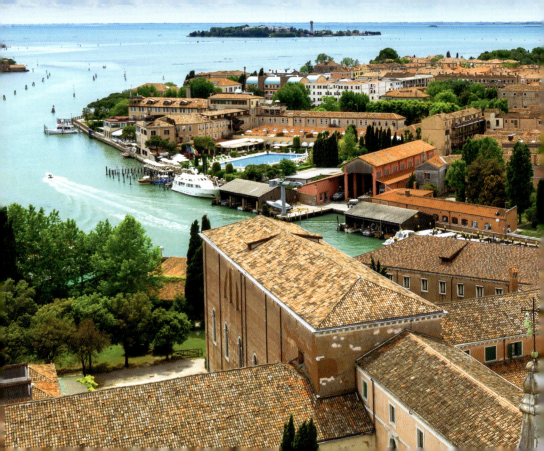

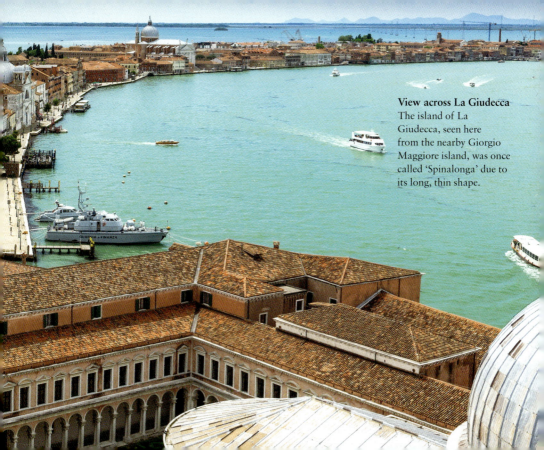

View across La Giudecca
The island of La Giudecca, seen here from the nearby Giorgio Maggiore island, was once called 'Spinalonga' due to its long, thin shape.

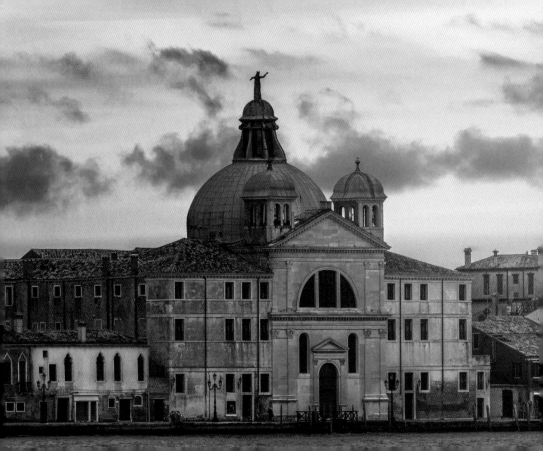

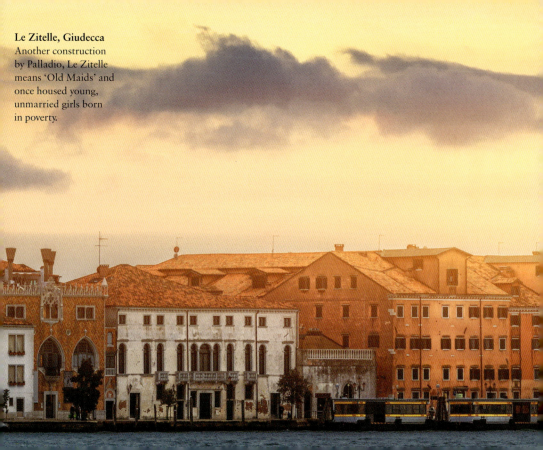

Le Zitelle, Giudecca
Another construction by Palladio, Le Zitelle means 'Old Maids' and once housed young, unmarried girls born in poverty.

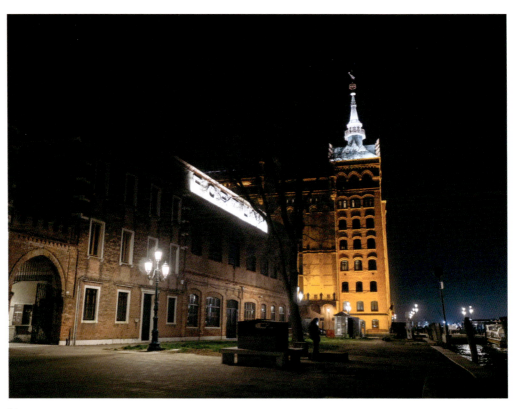

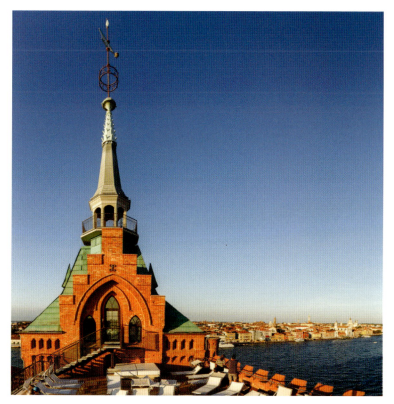

BOTH PHOTOGRAPHS:
The Molino Stucky building, Giudecca
The renovated flour mill was built by Giovanni Stucky in 1895 – he was later murdered by one of his employees in 1910. Now a Hilton hotel featuring a roof terrace (left), it is one of Venice's great emblems of industrialisation.

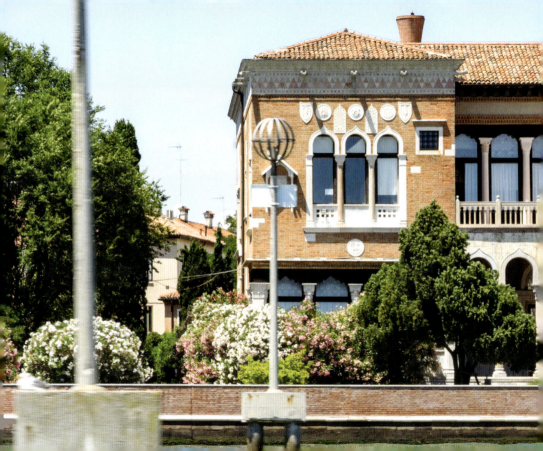

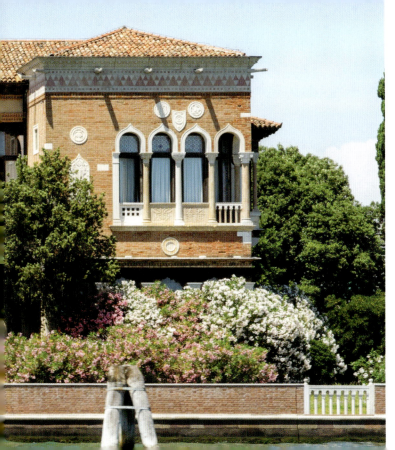

Villa Heriot, Giudecca
One of Giudecca's 'hidden' treasures is Villa Heriot, which once belonged to aristocrat and philanthropist Cyprienne Hériot and is now part of the International Institute of Art. The building has sweeping views across the lagoon and dates back to the 1920s.

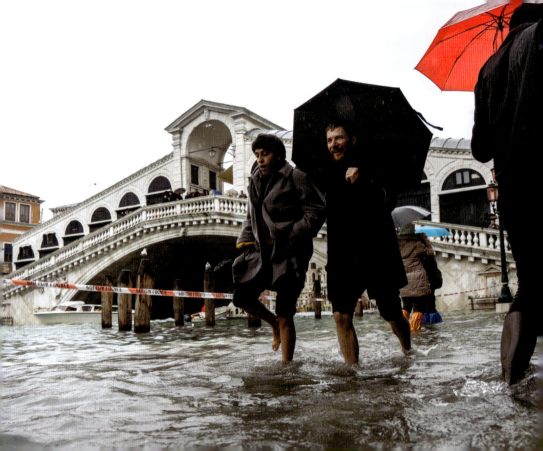

San Marco

The beating heart of Venice, San Marco is the smallest and most central district of the city, if not the most spectacular. Visitors flock here to soak up the beauty of the Piazza San Marco, perhaps the most famous square in the world. Dubbed the 'Drawing Room of Europe' by Napoleon, it is almost always heaving with tourists, yet remains a dazzling sight nonetheless. The public space is considered such a showpiece that no other squares in Venice are called 'piazzas' but rather '*campi*' or 'fields'.

At the eastern end of the square sits the Palazzo Ducale and the Basilica di San Marco, the city's most visited attractions. Take a stroll under the arcades of the imposing Procuratie Vecchie, that line the three other sides of the square, to find boutiques and historic cafes, such as the legendary Caffè Florian, which dates back to 1720 and is Italy's oldest café.

Away from the Piazza, you can quickly escape the throngs. Crisscross along narrow *calli* following the snaking Grand Canal or head north along the Mercerie, a series of shop-lined streets that will lead you to the Rialto Bridge. You'll pass plenty of designer shops, but hunt out the authentic stores which sell typically Venetian mementoes, such as hand-painted masks, artisan stationery and hand-crafted jewellery.

OPPOSITE:
Acqua Alta in Piazza San Marco
Situated so close to the lagoon, Piazza San Marco is often the first place to get flooded by *aqua alta* (high water) which occurs when the surrounding water levels rise between autumn and spring.

NEXT PAGES:
Bridge of Sighs
The Ponte dei Sospiri (Bridge of Sighs) dates back to 1600 and was built to link the Palazzo Ducale with the New Prisons. Its name is taken from the sound of the condemned prisoners sighing as they had their last glimpse of the lagoon through the grilled windows.

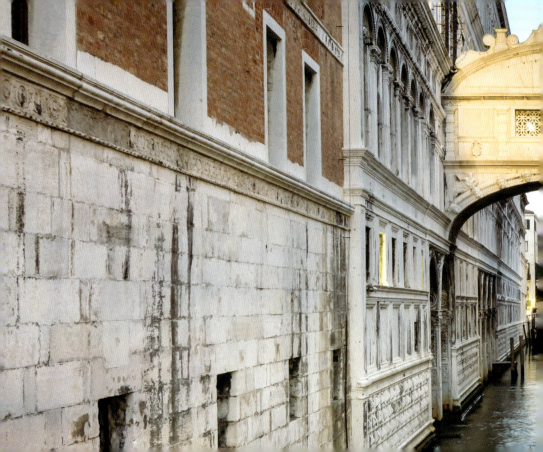

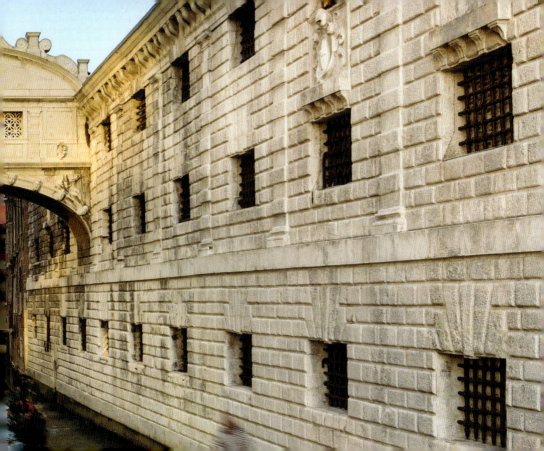

ALL PHOTOGRAPHS:
Caffè Florian
One of the most famous places to sip coffee (or, in fact, hot chocolate – Casanova's favourite drink), Caffè Florian has welcomed the good and the great over the years, including Casanova, Lord Byron, Marcel Proust and Charles Dickens. The interior shimmers with 300-year-old classical architectural details, gilded mirrors and red velvet seating.

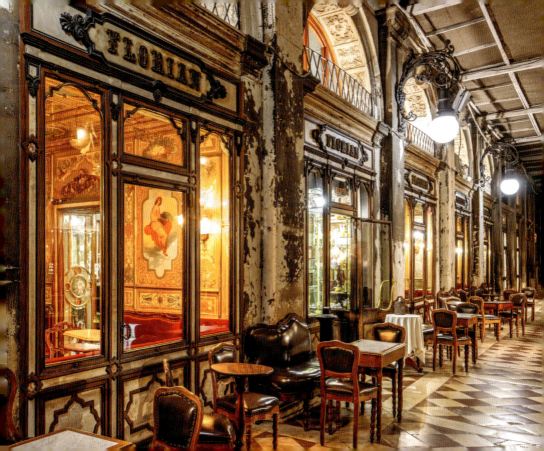

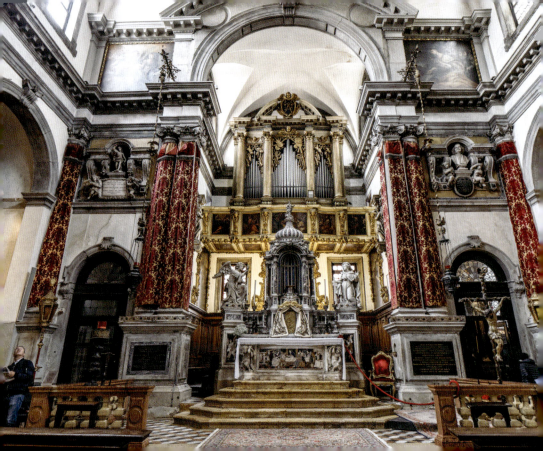

ALL PHOTOGRAPHS:
Chiesa di Santa Maria del Giglio
Dating back to the ninth century is the church of Santa Maria del Giglio. Inside are two canvases by Tintoretto as well as the *Madonna and Child with St John* by Peter Paul Rubens – the only painting by the artist in Venice. Causing controversy at the time, the main statues on the façade are not of religious figures, but rather of the Barbaro brothers who paid for the rebuilding of the church in 1678.

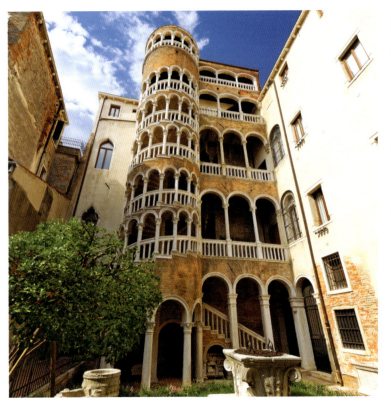

ALL PHOTOGRAPHS:
Palazzo Contarini del Bovolo
This hidden treasure of a palace, close to Campo Manin, is best known for its spiral staircase that was added in 1499 and that leads to the top of the tower, giving views over the city's rooftops. Its name 'Bovolo' means 'snail shell'.

OVERLEAF:
Columns, Palazzo Ducale
Dating back to the ninth century, the Palazzo Ducale (Doges Palace) was the official residence of 120 doges, who ruled Venice from 697–1797.

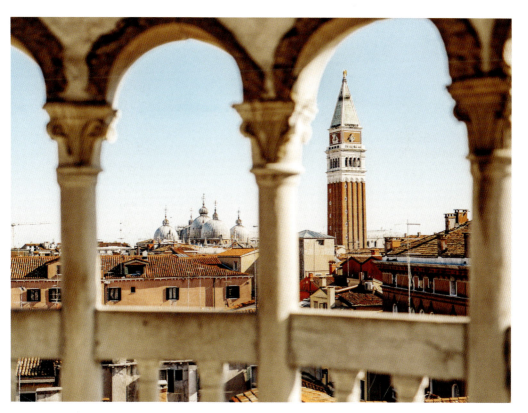

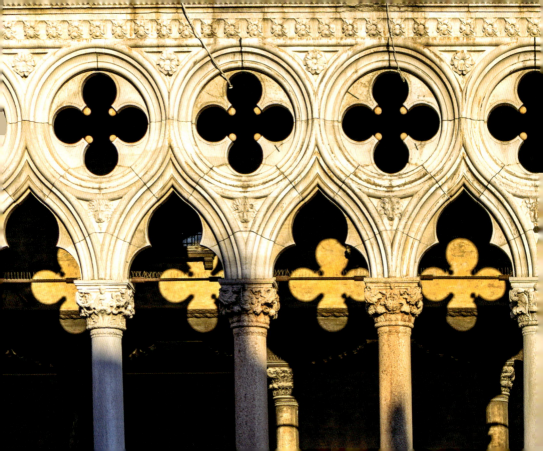

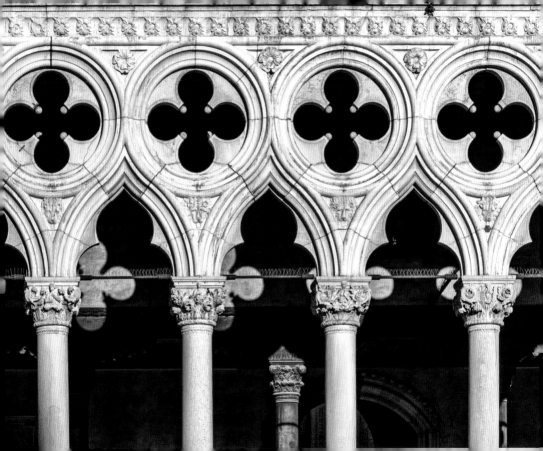

RIGHT:
Palazzo Ducale
The palace has two distinct facades, built in Venetian Gothic style, with colonnaded levels and pink inlaid marble, one facing Piazza San Marco and the other overlooking the lagoon. The third side faces a canal, Rio di Palazzo, which is crossed by the Bridge of Sighs.

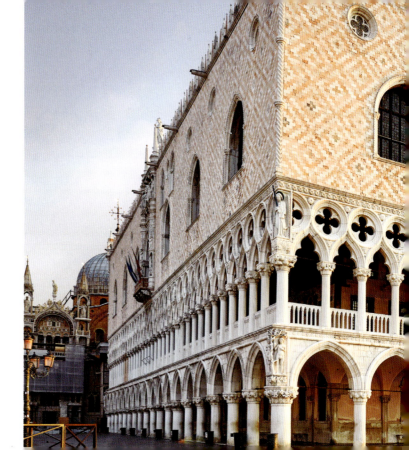

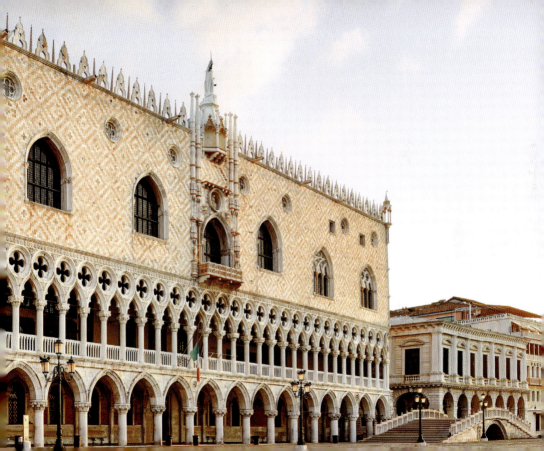

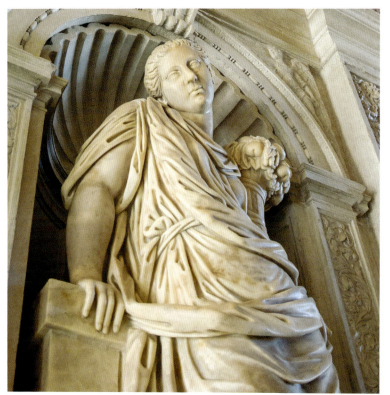

ALL PHOTOGRAPHS:
Palazzo Ducale
Now a museum, the Palazzo Ducale has been rebuilt many times over the years and features a variety of architectural details, such as the *Scala d'Oro* (Golden Staircase), as well as artistic gems, such as work by Titian, Tintoretto and Bellini.

Palazzo Ducale
The majestic Sala del Maggior Consiglio features Tintoretto's *Paradise* on the eastern wall – an epic work that is one of the longest oil paintings in the world.

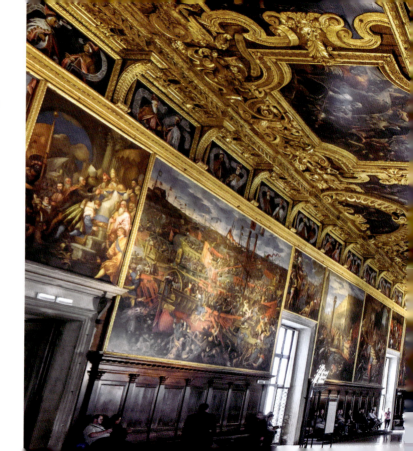

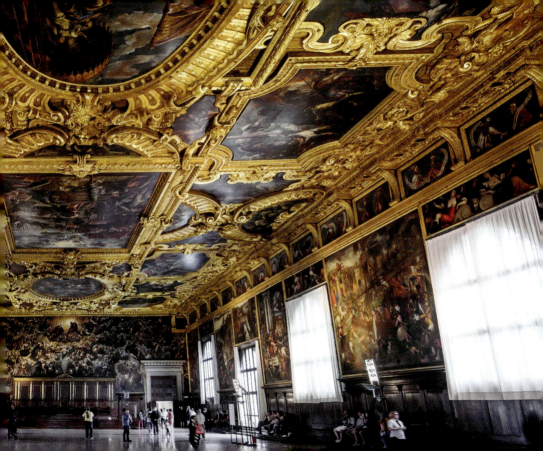

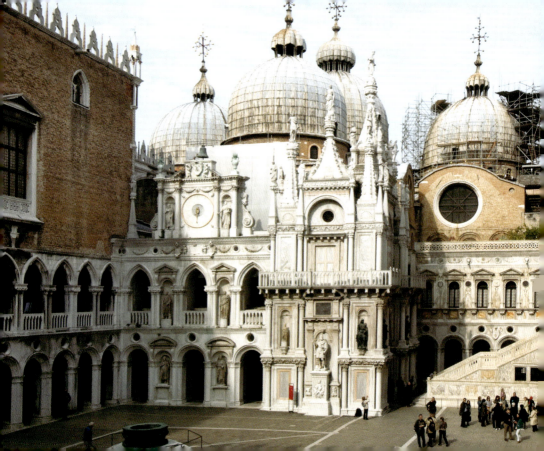

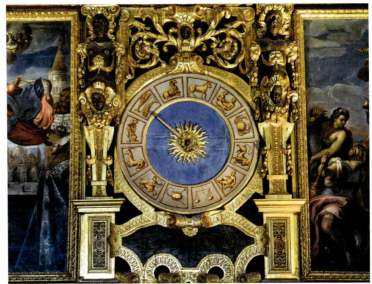

LEFT:
The Courtyard, Palazzo Ducale
The courtyard gives a view of the domes of the Basilica di San Marco. The Giants' Staircase, marked by Sansovino's two statues of Mars and Neptune, was once used for formal entrances into the palace.

ABOVE:
Zodiac Clock, Palazzo Ducale
Found in the Senate Chamber of the palace, the ornate clock features a zodiac calendar and intricate mechanical workings dating back to the Renaissance era.

ABOVE:
The Torture Chamber, Palazzo Ducale
You can still see where prisoners were hung from their wrists in the middle of the room until they confessed to their crimes.

RIGHT:
The Dungeons, Palazzo Ducale
The *Pozzi* are the dungeons, where some of the graffiti from the convicts remains.

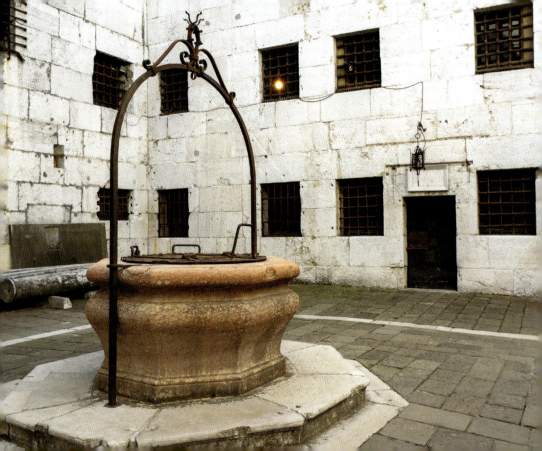

ALL PHOTOGRAPHS:
The New Prisons
The Ponte dei Sospiri (Bridge of Sighs, below) links the Palazzo Ducale to the New Prisons (built in 1556). From the courtyard, the barred windows have an ominous presence.

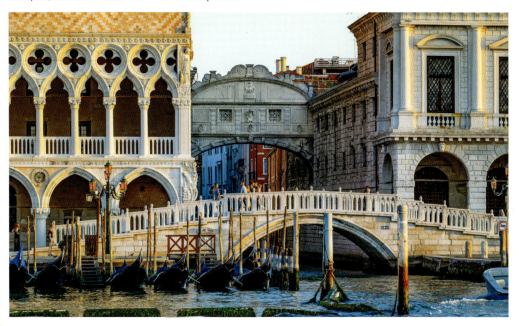

RIGHT:
Gondolas
Snow-covered gondolas are lined up in the winter months on the Grand Canal – known by Venetians as the Canalazzo – with the Rialto Bridge in the background.

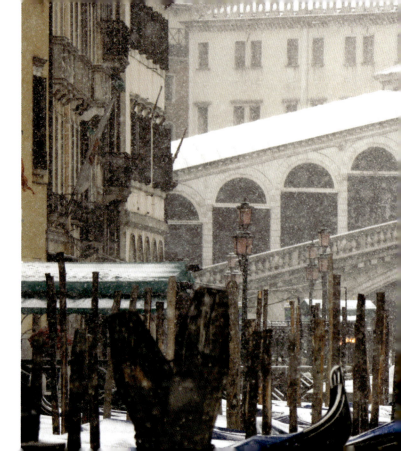

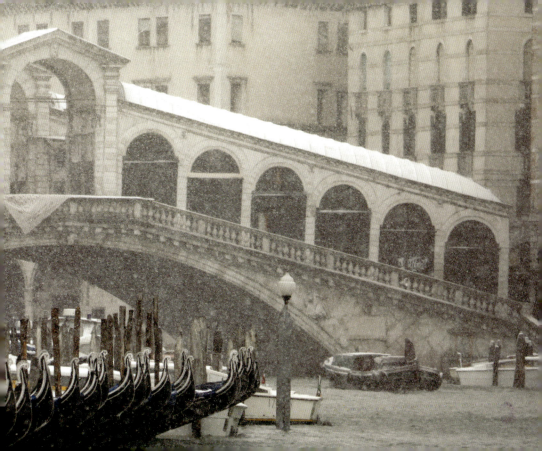

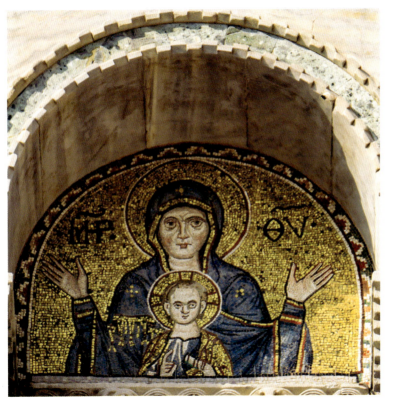

LEFT:

Basilica di San Marco
The cathedral is one of Europe's most splendid, and it blends the architectural styles of East and West, featuring golden mosaics and icons that embellish its exterior and interior.

OPPOSITE:

Gilded Bronze Horses
Inside the Basilica is the Museo Marciano, where the impressive sculptures of four horses can be seen. They are believed to date back to the second or third century AD.

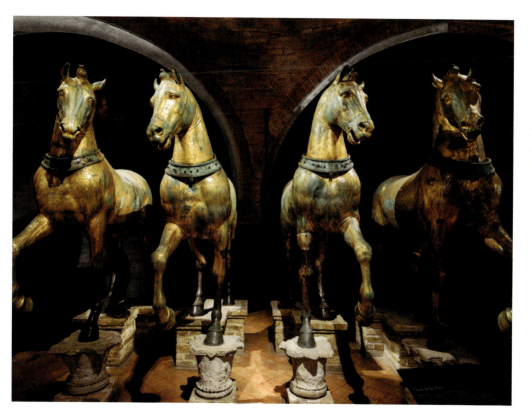

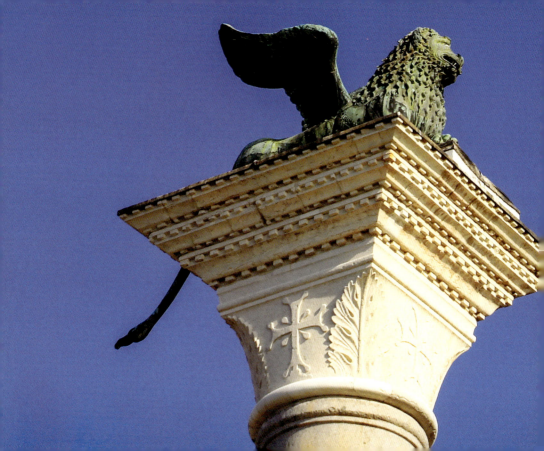

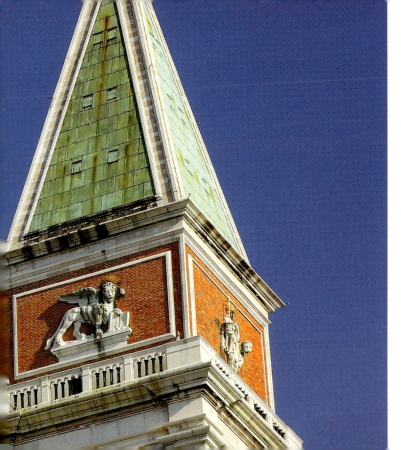

LEFT:
The Winged Lion
The winged lion, seen here on top of the column in Piazza San Marco, can be seen throughout the city. It represents St Mark the Evangelist, the patron saint of Venice.

OVERLEAF:
Teatro La Fenice
Originally built in 1792, La Fenice, the city's main theatre, is famous for its opulent interior and its links with famous composers such as Verdi and Rossini. It has burnt down and been rebuilt twice – in 1836 and 1996.

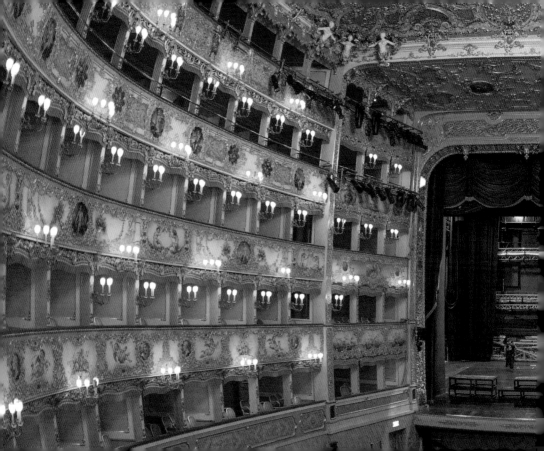

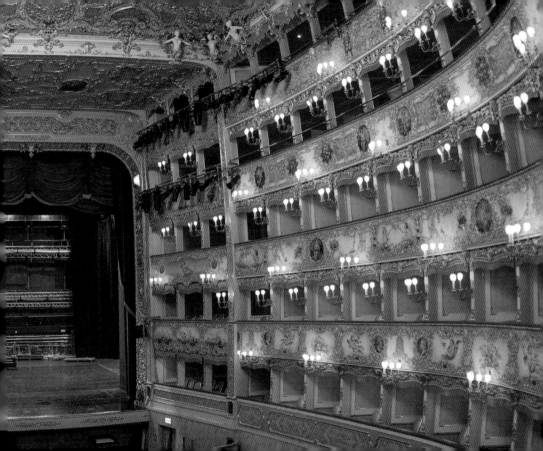

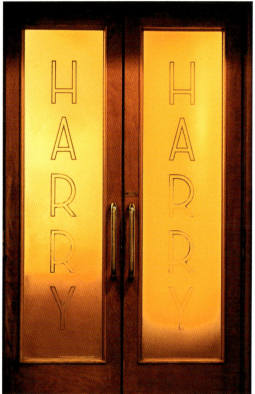

ALL PHOTOGRAPHS:
Harry's Bar
Opened in 1931 by Giuseppe Cipriani, the legendary Harry's Bar – named after the American Harry Pickering, who bankrolled it – was where the Bellini cocktail was invented (made with prosecco and white peach puree). From the mahogany bar to the starched linen tablecloths, the bar and restaurant oozes a timeless appeal.

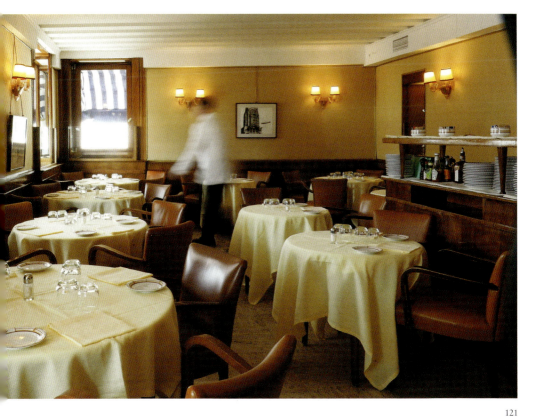

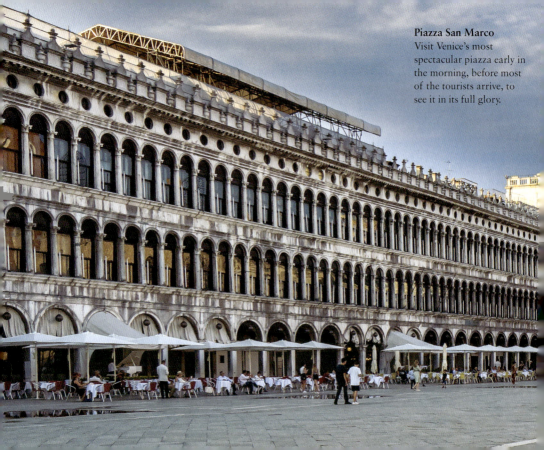

Piazza San Marco
Visit Venice's most spectacular piazza early in the morning, before most of the tourists arrive, to see it in its full glory.

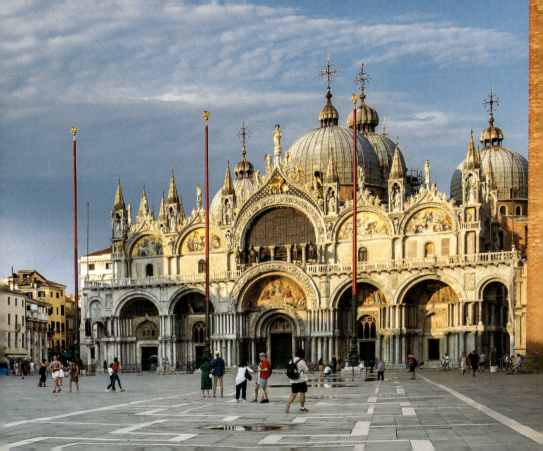

Campanile of San Marco
One of the most recognisable symbols of Venice is the Campanile. It was originally built in 1173 as a watchtower and lighthouse but has been rebuilt and renovated over the years. From the top, you can see glorious views across the city and the lagoon.

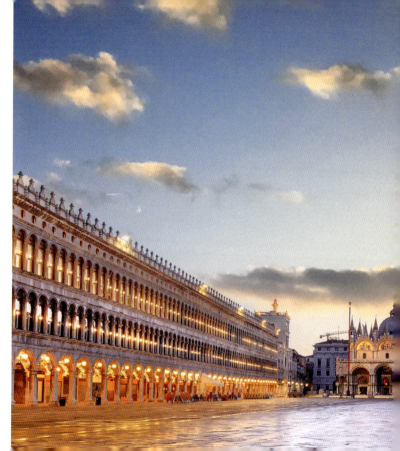

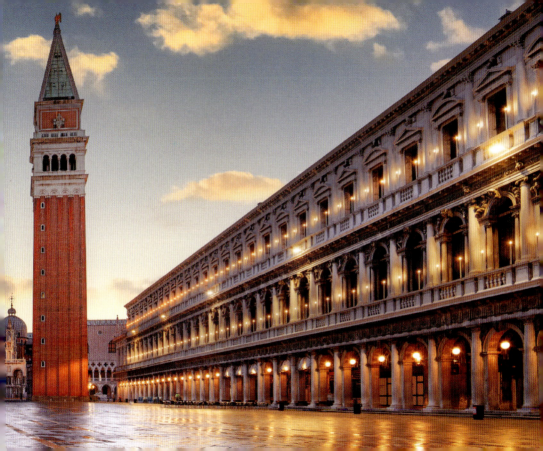

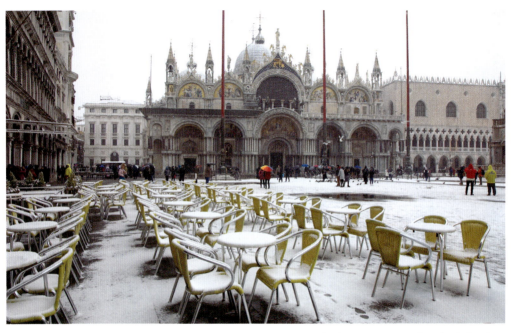

ALL PHOTOGRAPHS:
Piazza San Marco
Visit the city in winter to capture its real charm. Fog rolls in from the lagoon, shrouding the canals and narrow *calli* in a romantic veil of mist. Without the summer crowds, the city seems to sigh with relief and you can stroll around its major sites with ease.

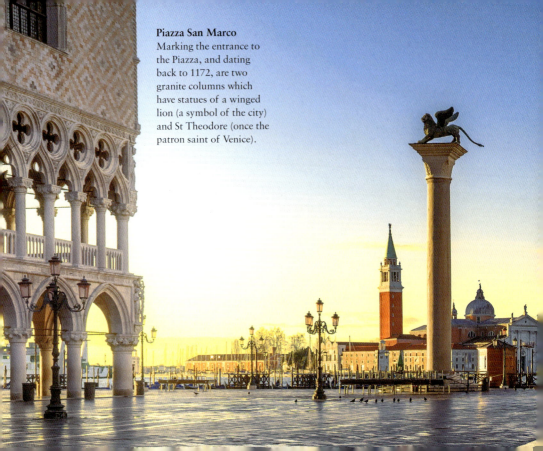

Piazza San Marco
Marking the entrance to the Piazza, and dating back to 1172, are two granite columns which have statues of a winged lion (a symbol of the city) and St Theodore (once the patron saint of Venice).

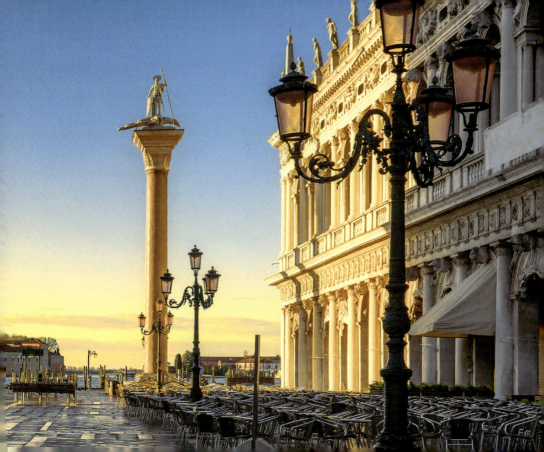

San Giorgio Maggiore
The St George statue sits on the dome of the church of San Giorgio Maggiore which, along with a complex which housed a monastery, is found on the island of Giorgio Maggiore.

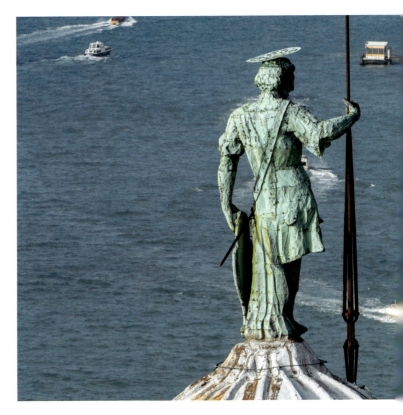

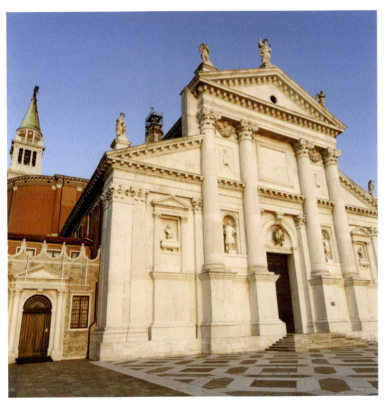

ALL PHOTOGRAPHS:
San Giorgio Maggiore
One of Venice's most recognisable landmarks, the church was built between 1559 and 1580 and was designed by Palladio (but completed after his death). It can be seen from San Marco and its façade famously catches the day's changing light. Inside are ornate carved wooden chapels (right) and artwork by Tintoretto.

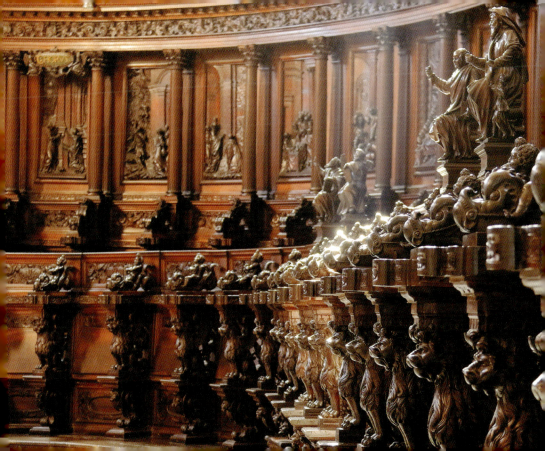

OPPOSITE:

The Cini Foundation
San Giorgio Maggiore's monastery was bought by Count Vittorio Cini in 1951 and relaunched as a cultural centre. Today it hosts events and exhibitions. Pictured here, *Bermuda Triangle* by Marc Quinn, was part of a previous Cini Foundation exhibition at San Giorgio Maggiore.

RIGHT:

Faro San Giorgio
The small lighthouse at the edge of San Giorgio dates from 1813 and marks where a small harbour is found alongside the church.

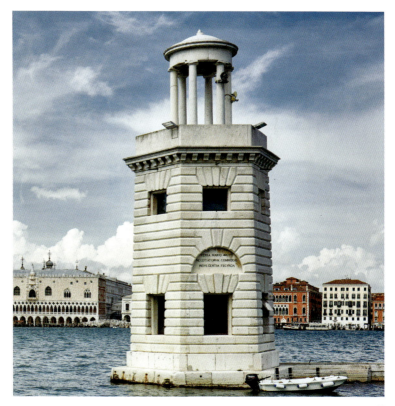

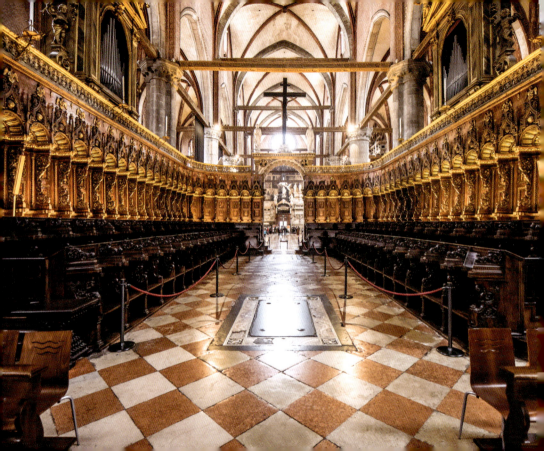

San Polo

Don't be misled by the fact that San Polo is the smallest *sestiere* in Venice. The district still packs a punch with its star attraction – the Rialto Bridge. One of the city's oldest areas, it's where some of the first inhabitants settled, moving from the lagoon islands in the ninth century. The Rialto – meaning 'high bank' – offered them higher land away from potential floods.

Known for the bustling Rialto Market, where Venetians have shopped for fish, fruit and vegetables for hundreds of years, San Polo is also somewhat of a foodie hub, with its narrow streets lined with authentic *bacari*, selling typical *cicchetti* (small plates) and *oseterie* serving local wines and traditional Venetian dishes.

The vibrant area is named after Campo San Polo, the second largest square after Piazza San Marco. San Polo is also home to what is thought to be the oldest church in the city, San Giacomo di Rialto, which dates back to the fifth century, and the largest, Basilica dei Frari.

Away from the busy Rialto Bridge, the area is made up of warren-like passageways, sunny squares and meandering canals, meaning you can soak up plenty of Venice's quiet charm. The area is found in the upper curve of the Grand Canal, which is lined with a line-up of historic Gothic *palazzi* – giving a glimpse into the area's aristocratic heritage.

OPPOSITE:
Basilica di Santa Maria Gloriosa dei Frari
Often shortened to the 'I Frari', this vast Gothic church was built by Franciscan friars, taking them over 100 years from 1250 to 1398. The choir stalls, seen here, are made up of 124 wooden seats painted with Venetian scenes and were designed by the artist Marco Cozzi in 1468.

RIGHT:
Triptych by Bellini, Santa Maria Gloriosa dei Frari
The *Madonna with Child and Saints* triptych was painted by Giovanni Bellini in 1488 and is found on the altar of the sacristy. It is considered one of the finest pieces of Renaissance art.

OPPOSITE:
The nave of Santa Maria Gloriosa dei Frari
The church has three naves inside, divided by 12 pillars, to represent the 12 apostles.

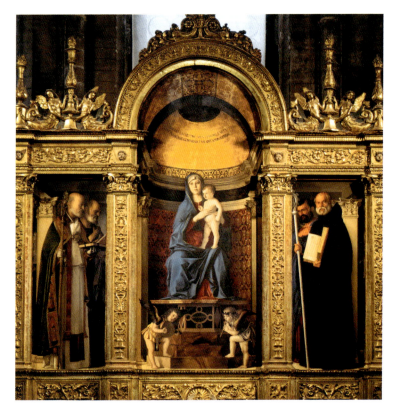

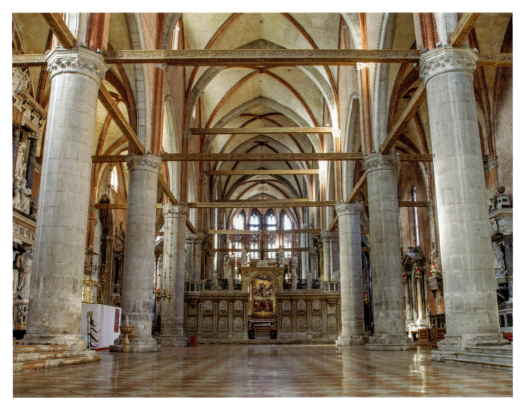

Painting by Titian, Santa Maria Gloriosa dei Frari
Titian's *The Assumption of the Virgin* is another masterpiece found inside the church.

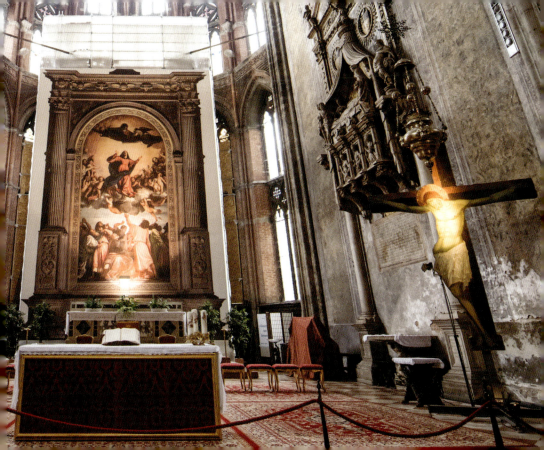

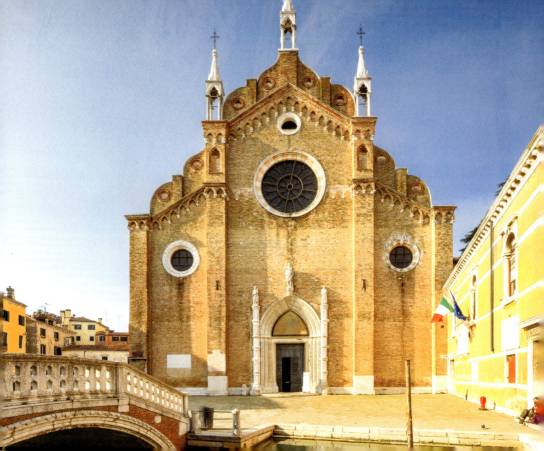

OPPOSITE:
Basilica di Santa Maria Gloriosa dei Frari
The outside of the church, found in Campo dei Frari, may look nondescript, but its doors give way to a host of treasures within.

RIGHT:
Cantina do Mori
The oldest *bacaro* (wine bar) in Venice is found close to the Rialto Bridge and dates back to 1452. According to legend, this is where Casanova would bring his lovers.

OPPOSITE:
Scuola Grande di San Rocco
Venetian *scuole* were set up as charitable organisations. This *scuola* features a stunning early Renaissance facade, as well as a collection of paintings by Tintoretto.

ALL PHOTOGRAPHS:
Leonardo da Vinci Museum
Found adjacent to the Scuola Grande di San Rocco is the interactive Leonardo da Vinci Museum featuring replicas of Leonardo da Vinci's inventions and machines, as well as some of his drawings and paintings.

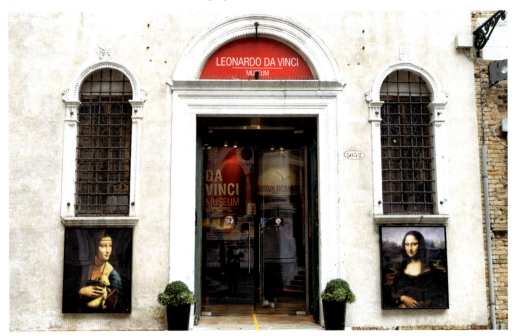

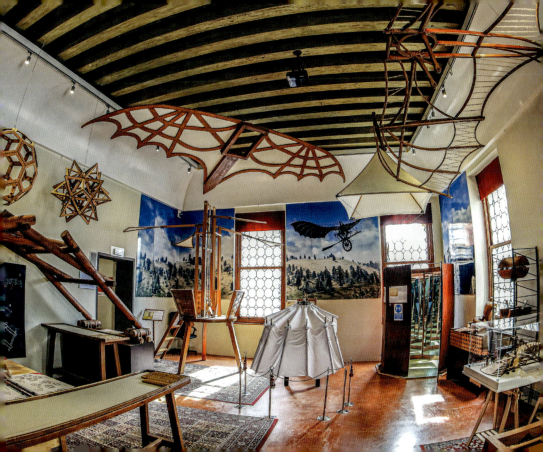

RIGHT:
Stairway, Scuola Grande di San Rocco
The grand staircase is decorated with works by Antonio Zanchi, Pietro Negri and a fresco inside the cupola by Giovanni Antonio Fuminani.

FAR RIGHT:
Painting by Tintoretto, Scuola Grande di San Rocco
The Vision of St. Roch by Tintoretto is one of over 50 paintings by the artist at the Scuola. Many have no exact names as he was simply commissioned to decorate the walls and ceilings of the Scuola.

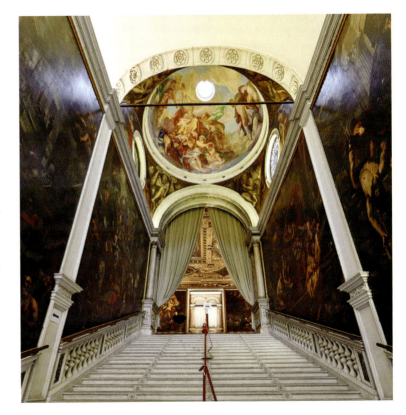

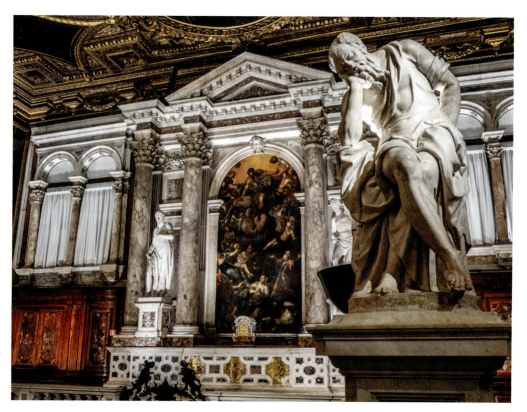

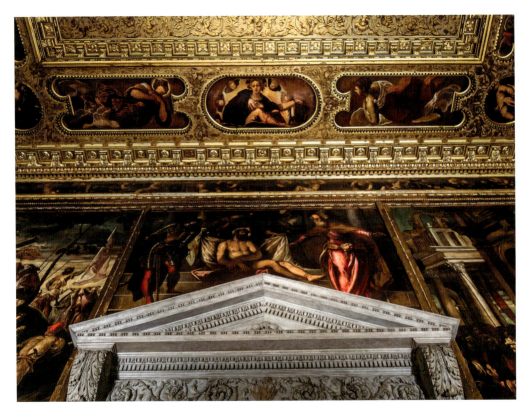

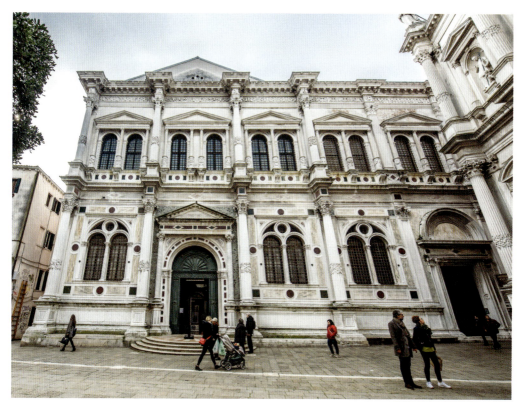

PREVIOUS PAGES
AND RIGHT:
**The Scuola Grande
di San Rocco**
The *scuole* of Venice were Christian institutions set up as charitable organisations. San Rocco was founded in 1478 to help the sick, in honour of the patron saint of St Roch, who helped plague victims in Italy. Its stately exterior is almost as impressive as the rich collection of art that lines the walls within.

FAR RIGHT:
The Scuola Grande di San Giovanni Evangelista
The Scuola Grande di San Giovanni Evangelista is one of oldest 'schools' in Venice, dating back to 1261.

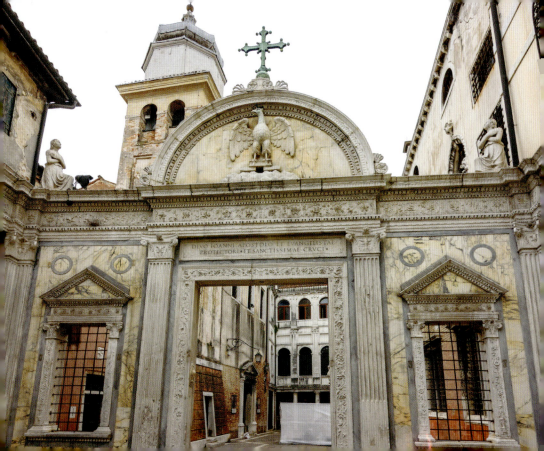

Aerial shot of Venice
The Grand Canal snakes around the warren of streets that make up San Polo.

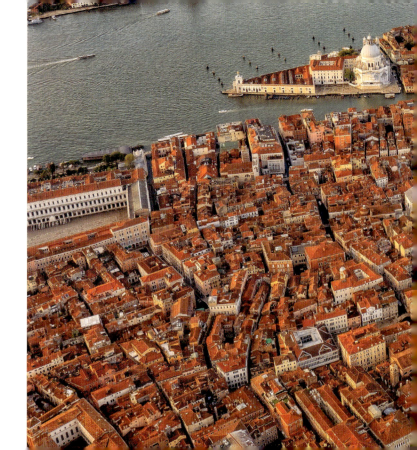

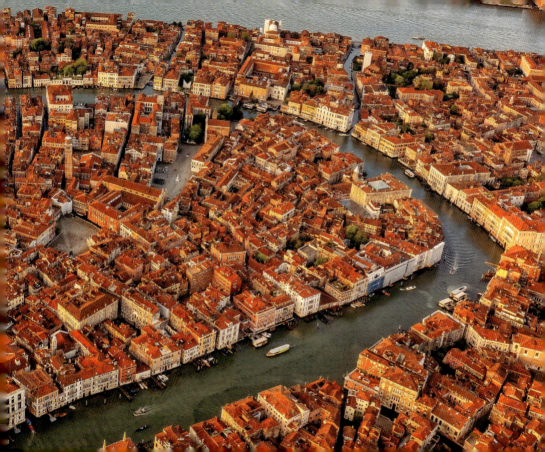

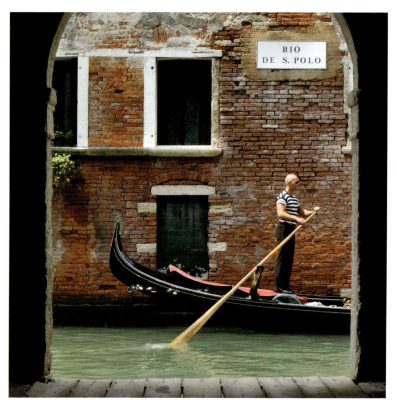

ALL PHOTOGRAPHS:
Rio de San Polo
Take a gondola along Rio de San Polo (left), an artery off the Grand Canal, to discover the quieter side of San Polo. The Ponte San Polo crosses this canal and, after a short walk, leads to the beating heart of the district, Campo San Polo.

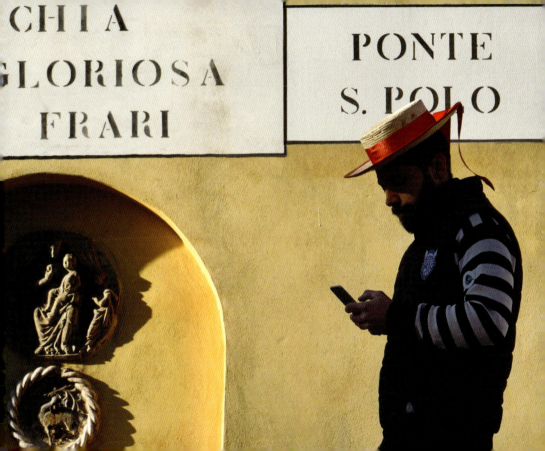

The Grand Canal

Taking a gondola along the bustling Grand Canal is the best way to soak up the views of the palazzi that line this stretch of the waterway.

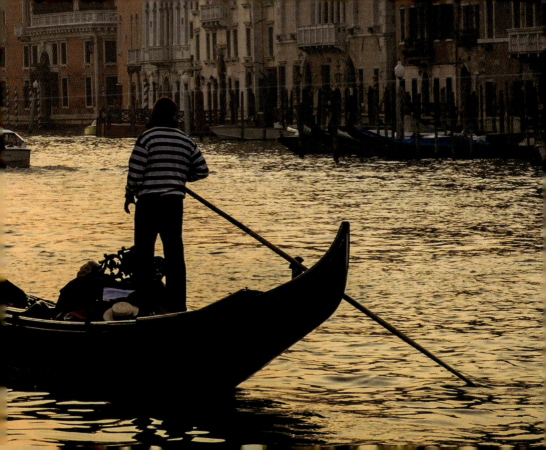

ALL PHOTOGRAPHS
Campo San Polo
Several palaces are found in the large square that is Campo San Polo as well as the church of San Paolo Apostolo. It is also known as San Polo church, and is home to the *Last Supper* painted by Tintoretto in 1568.

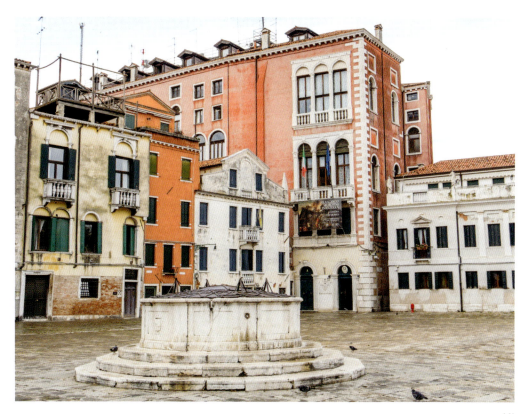

OPPOSITE:
Workshop of an artisan shoemaker
San Polo is sprinkled with artisan shops, such as the atelier owned by shoemaker Gabriele Gmeiner, who creates bespoke footwear from her workshop.

RIGHT:
Caffè Vergnano 1882
This coffee bar is found at the Rialto Market. It has been carved out of an old warehouse, with views over the Grand Canal.

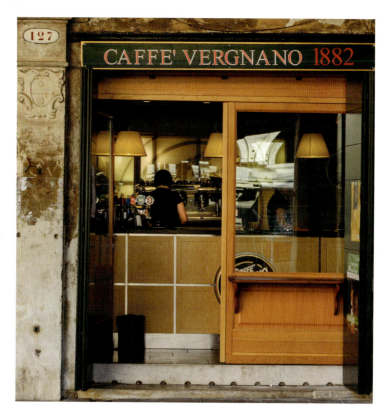

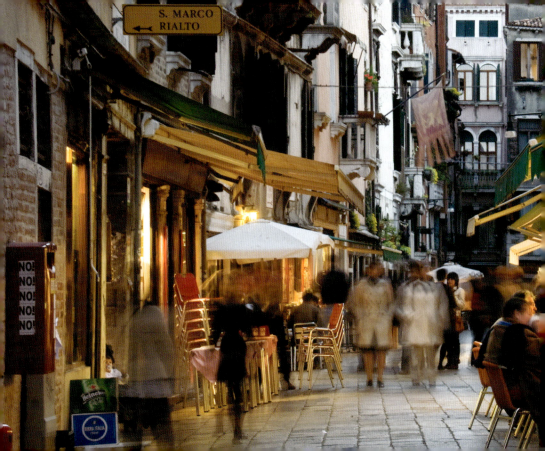

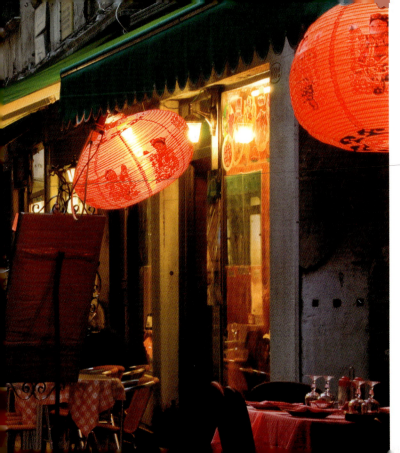

Calle dei Boteri
Now lined with restaurants and cafes, this street takes its name from the '*boteri*', the ancient makers of barrels, who learnt their skill here and were obliged to make barrels for the doges for free.

ALL PHOTOGRAPHS:
Casa di Goldoni
Carlo Goldoni was one of the city's most prolific playwrights, and his home, The Palazzo Centani, is now a theatrical art museum and a centre for theatrical studies. Known as Casa di Goldoni, its 15th century courtyard has an open staircase and ornate well-head.

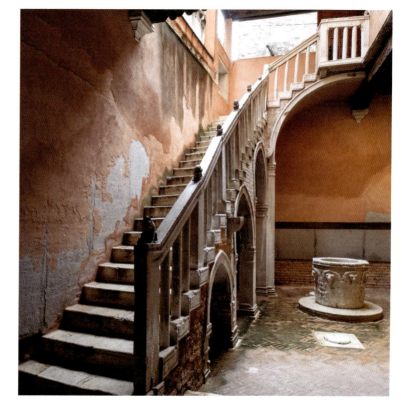

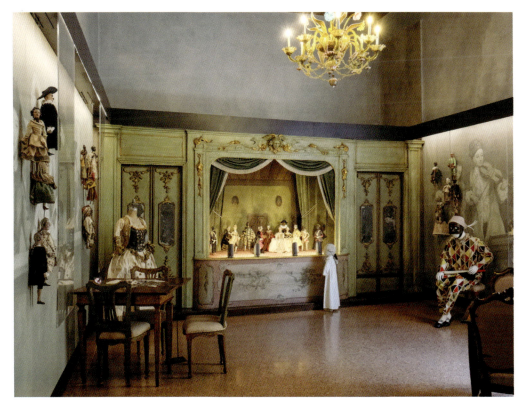

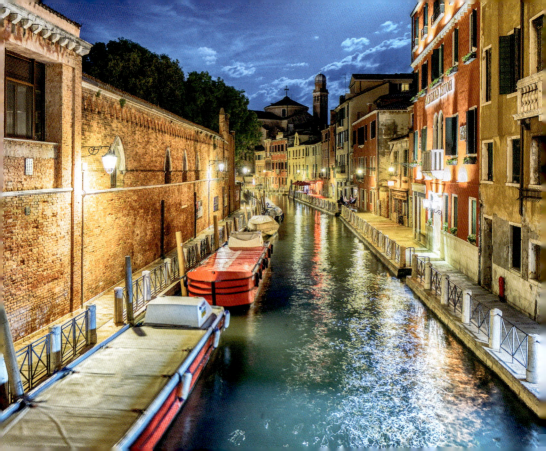

Santa Croce

Perhaps the most understated district of Venice, Santa Croce, which lies to the west of the city and north of San Polo, is the first neighbourhood visitors will encounter when they arrive by air, car or bus.

Piazzale Roma is the main transport hub. It is home to the bus terminal, which connects travellers to the airport and vies with Piazza San Marco for being one of the busiest spots in the city. But, away from the hubbub of the square, the district feels the most local, with Venetians busying themselves with their everyday lives. It's the perfect place to stroll around or take a gondola along the still canals.

While there aren't many of the big showstopping monuments found in Venice's other *sestiere*, Santa Croce has its own allure: you'll cross meandering streets where locals meet at lively trattorias; or come across quiet corners that feel off the beaten track. Because of this, it is home to many under-the-radar restaurants and *bacari*, frequented by locals and serving authentic Venetian cuisine.

The gem of Santa Croce is Ca' Pesaro, one of the most important museums of Modern Art in Italy, which sits proudly on the Grand Canal. The Natural History Museum gives a different insight into the history of this great city. The church of San Giacomo dell'Orio is also worth a visit and is found in the Campo San Giacomo dell'Orio, which sits at the heart of Santa Croce.

OPPOSITE:
Local canals
A quiet area, Santa Croce offers tranquil back-canals and atmospheric walkways.

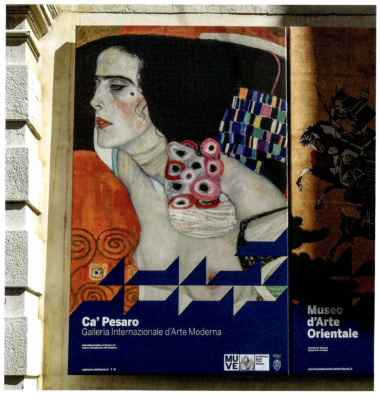

ALL PHOTOGRAPHS:
Ca' Pesaro International Gallery of Modern Art
The gallery contains a vast collection of 19th and 20th century works of art and is found in a Baroque palace that dates back to the 17th century. The wealthy Pesaro family commissioned Baldassarre Longhena, who also designed Santa Maria della Salute and Ca' Rezzonico, to build the magnificent palazzo.

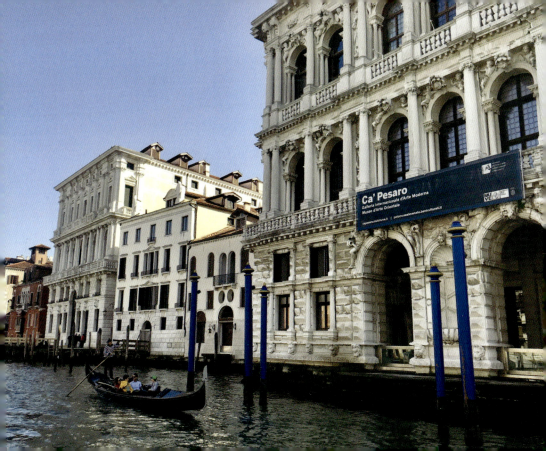

...itotto e dintorni

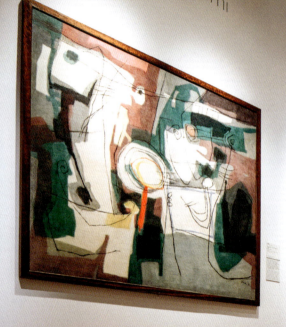

ALL PHOTOGRAPHS:
Ca' Pesaro International Gallery of Modern Art
Ca' Pesaro is full of important works of art, such as pieces by Rodin and Klimt. Other works include: *Estemplare No. 3: Villa Fleurent* (1952) by the Italian Modernist painter Afro Basaldella (opposite) and *Spectre is Haunting Europe* (1950) by Armando Pizzinato (above).

173

Chiesa di San Giacomo dell'Orio
Founded in the ninth century, this church was later rebuilt in the 13th century and has been continuously modified; thus visitors will find a mix of architectural styles. The main apse reveals its Byzantine roots.

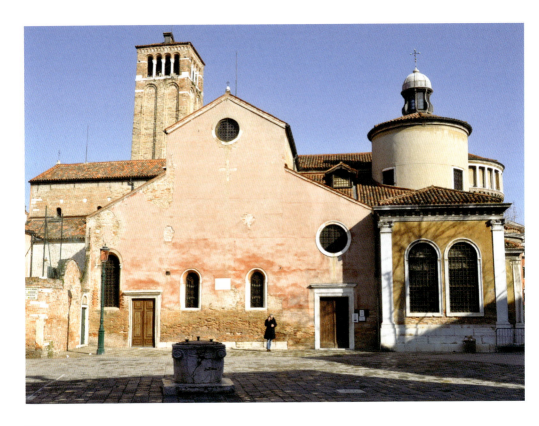

OPPOSITE:
Chiesa di San Giacomo dell'Orio
The church looks quite ordinary from the outside, but, inside, notable architectural details include a ship's keel ceiling of carved wood and a rare piece of art, *Virgin Mary and Child with Apostles and Saints*, by Venetian artist Lorenzo Lotto.

RIGHT:
Chiesa di San Nicolò da Tolentino
This grand church, found close to Piazzale Roma, has an impressive Corinthian portico and is filled with 17th century paintings.

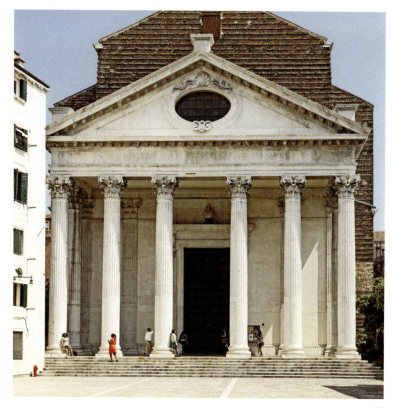

ALL PHOTOGRAPHS:
Chiesa di San Simeon Piccolo
Found opposite Santa Lucia train station, overlooking the Grand Canal, the majestic green dome of the church of San Simeon Piccolo is the first true Venetian sight visitors have when arriving by train. The current structure dates back to the 18th century.

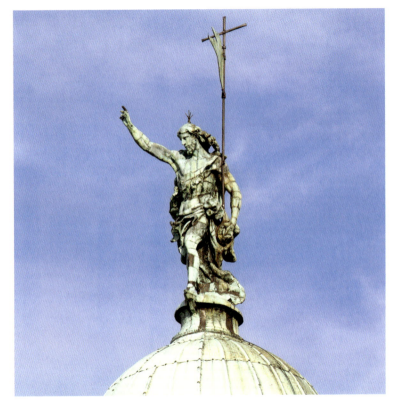

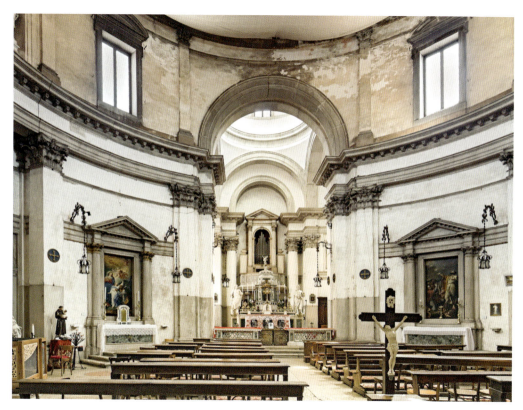

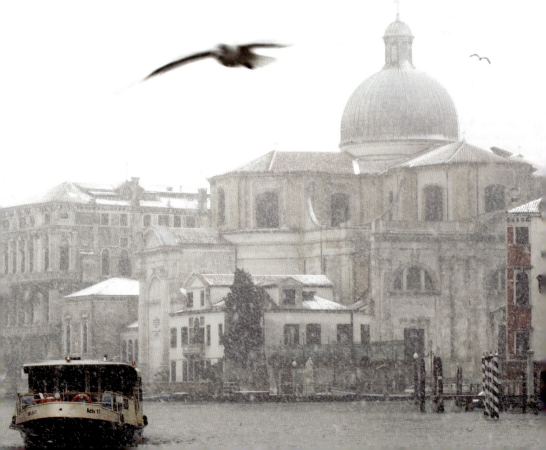

OPPOSITE:
The Grand Canal
Whatever the season, Venice boasts magical moments. In the winter months, the city has its own poignant beauty.

RIGHT:
Calle del Spezier
A quiet street and canal in Santa Croce gleams in the morning light.

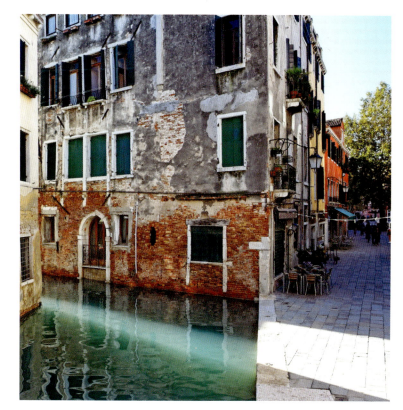

Museo di Storia Naturale
As well as fossils, dinosaurs and plenty of stuffed animals, the Natural History Museum also showcases Venice's golden era of exploration, with exhibits on adventurers such as Giovanni Miani who set out to find the source of the Nile.

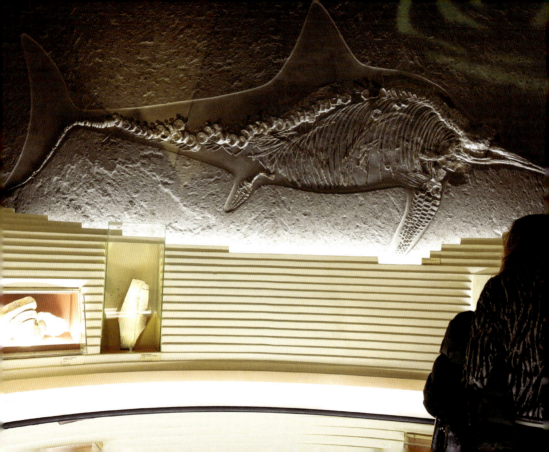

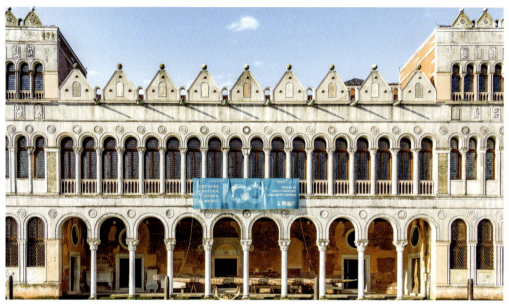

ALL PHOTOGRAPHS:
Museo di Storia Naturale
The Natural History Museum has had a home in the Fondaco dei Turchi, a palazzo dating back to the 13th century, since 1923. As well as aquatic exhibitions, it houses a Room of Wonders, created from the collections of explorers and travellers.

ALL PHOTOGRAPHS:
Giardini Papadopoli
These gardens in Santa Croce are a green haven in the city and are found close to the Piazzale Roma. The statue of Pietro Paeleocapa (left), a prominent Italian scientist and politician (1788–1869), dates from 1873.

Ponte della Costituzione
Opened in 2008, this is the fourth bridge that crosses the Grand Canal and connects Santa Lucia station to Piazzale Roma.

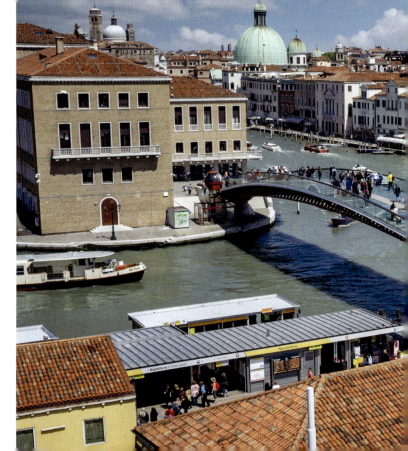

188

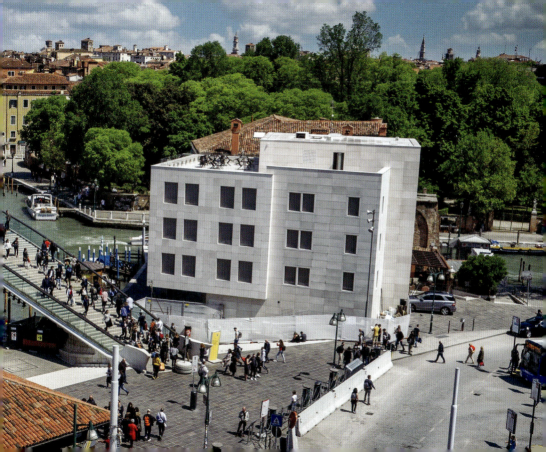

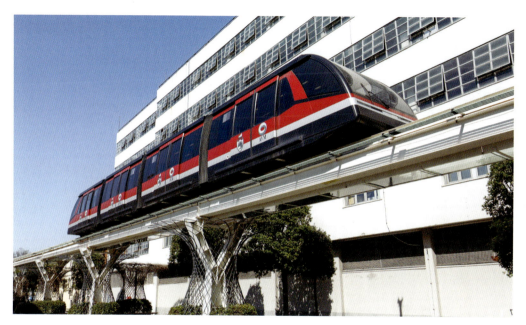

OPPOSITE:
Ponte della Costituzione
Designed by Santiago Calatrava, the glass bridge welcomes visitors to the stunning city, and is often known as the Calatrava Bridge.

ABOVE:
Shuttle train
This 'People Mover' is an automated, elevated transport system to connect travellers from Piazzale Roma to Tronchetto, where visitors can leave their cars.

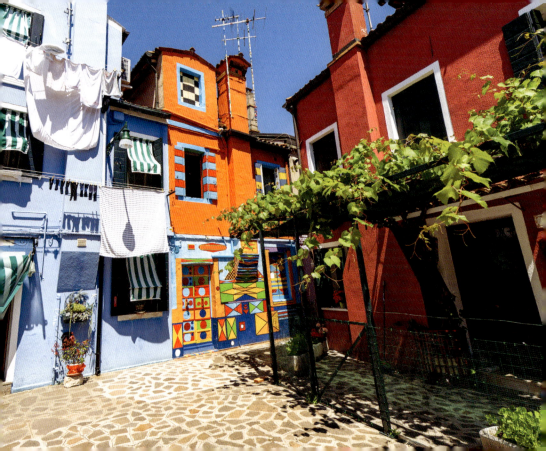

Outer Islands

As well as the 118 tiny islands that make up Venice, there is also a collection of larger lagoon islands to explore. Some, such as Burano, Murano and Torcello, are situated to the north of the city, while others, including the Lido, are found to the south. The marshy land of the north was where the first dwellers in this region settled in the fifth and sixth centuries, with some of the landscape, with its tall grasses and low-flying cormorants, remaining the same today.

These days, around 30 islands are inhabited, with each boasting its own distinct character. It's easy to get around, with good water bus (*Vaporetti*) services zigzagging across the water to each archipelago.

San Michele houses the city's main cemetery. Murano, now world famous for its glass-blowing workshops and showrooms, was once home to some 30,000 Venetians and was a popular summer retreat for Venetian aristocrats in the 16th and 17th centuries. Burano, meanwhile, has waterways lined with candy-coloured houses and is home to artists and a handful of traditional lace-makers. Torcello, a 40-minute ride from San Marco, is the most remote and the oldest inhabited island, famous for its stunning Santa Maria dell'Assunta cathedral.

Meanwhile, the eight-mile-long Lido is largely a residential suburb. Once a fashionable resort town, its beaches and seaside hotels still call in a huge amount of visitors once the weather warms up.

OPPOSITE:

House of Bepi, Burano
Found on Burano, the House of Bepi is perhaps the most vibrant of the island's rainbow-coloured houses.

ALL PHOTOGRAPHS:
Burano
Many of Burano's houses are former fishermen's cottages and were originally painted different shades so that the fishermen could see their homes from their boats.

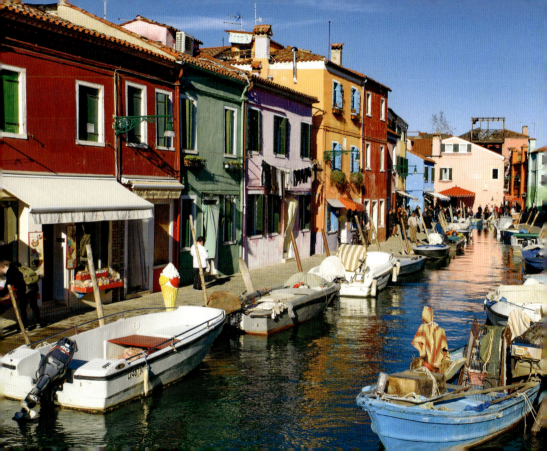

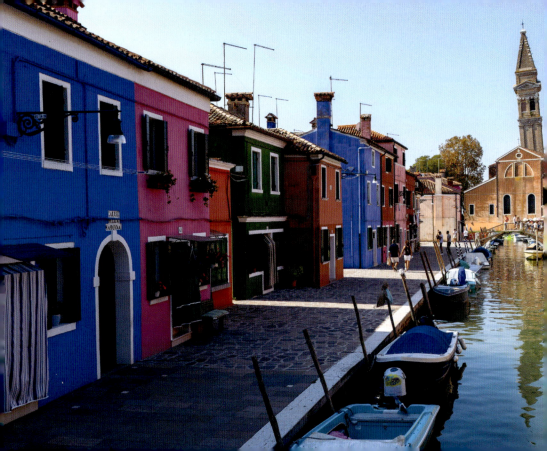

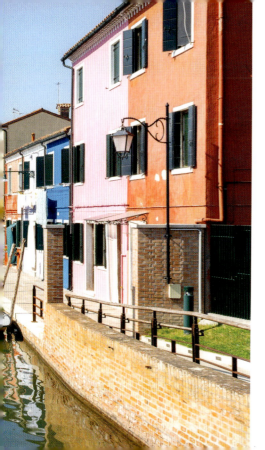
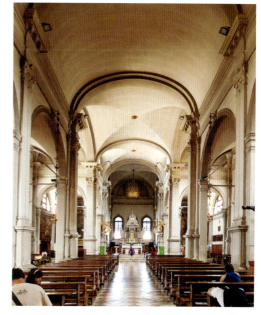

ALL PHOTOGRAPHS:
Chiesa di San Martino, Burano
The church of San Martino dates back to the 16th century and is distinctive because of its leaning campanile (left). Inside, is Giambattista Tiepolo's *The Crucifixion* painting.

Scuola del Merletto, Burano

Opposite San Martino is the Scuola del Merletto (School of Lace), which opened in 1872. While some classes in lacemaking are still offered, it operates largely as a museum to showcase the artisan skill that originated on the island.

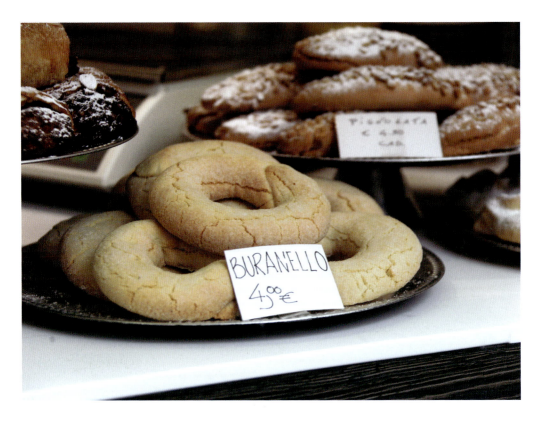

ALL PHOTOGRAPHS:
Traditional biscuits, Burano

Traditional Buranello biscuits – which also come in an 'S' shape – were originally baked by the fishermen's wives to give the men energy while at sea. They are still made on the island and can be found at bakeries, such as La Pasticceria Carmelina Palmisano (right).

201

ALL PHOTOGRAPHS:
Trattoria da Romano, Burano

This authentic Burano restaurant has been open for over 100 years. It is famous for its classic risotto, called 'Risi e Bisi', which is cooked with peas and the local fish, called Goby or Go (cooked in Venice since the 16th century). It is also renowned for its art collection that lines the walls, much of it created by artists who have eaten here.

202

OPPOSITE:
Amarone wine
For an authentic Venetian wine, opt for a bottle of Amarone, which comes from Valpolicella in the Veneto region, one of the most important wine-growing areas of Italy.

ABOVE:
Ausonia Hungaria, Lido
Built in 1905, this hotel has a unique façade of majolica tiles, which were added in 1913. The property is now a wellness hotel but gives a snapshot into a time when the island was a glamorous holiday destination.

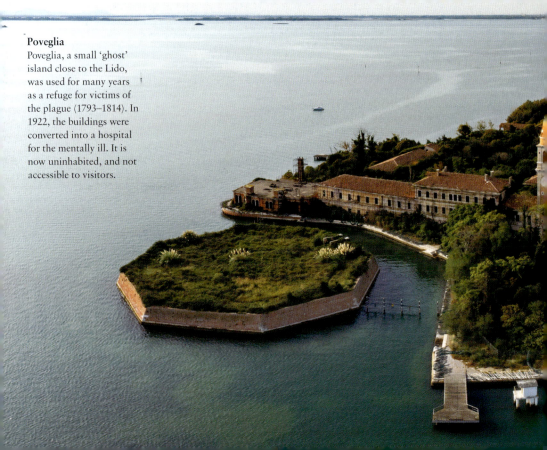

Poveglia

Poveglia, a small 'ghost' island close to the Lido, was used for many years as a refuge for victims of the plague (1793–1814). In 1922, the buildings were converted into a hospital for the mentally ill. It is now uninhabited, and not accessible to visitors.

LEFT:

Blue Moon beach, Lido
Blue Moon is one of the most popular public beaches on the Lido, found close to the centre of the island.

OPPOSITE:

Malamocco, Lido
The snow-capped peaks of the Dolomites are visible on a clear day from the small town of Malamocco on Lido Island.

Chiesa di San Pietro Martire, Murano
This Dominican church is one of only two churches still in service on Murano. Built in 1348, it was rebuilt in 1511 following a fire, and houses art by Paolo Veronese, Jacopo Tintoretto and Giovanni Bellini.

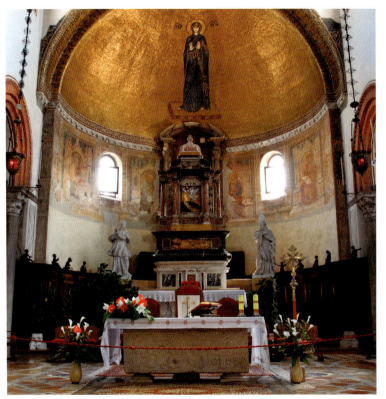

ALL PHOTOGRAPHS:
Chiesa di Santi Maria e Donato, Murano
The second notable church on Murano was founded in the seventh century and rebuilt in the 12th century. It is famous for its 12th century Byzantine mosaic floor, which features eagles and peacocks made of precious stones. The glorious gold apse (left), depicting the *Virgin in Prayer*, is also made of mosaics created from fragments of glass from the island's foundries.

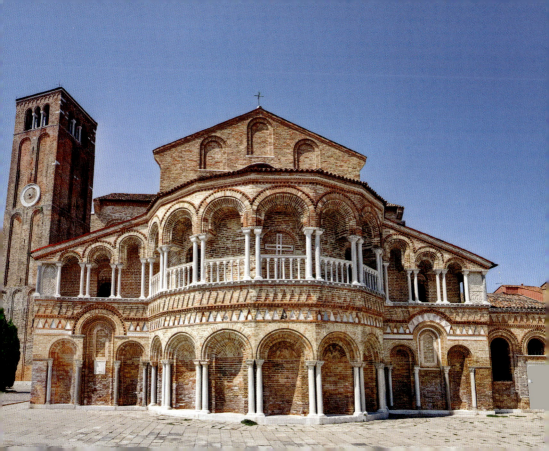

OPPOSITE:
Murano
Murano's glass-blowing industry dates back to the 15th century. A visit to the Museo del Vetro reveals more about this rich heritage.

RIGHT:
Glass blowing, Murano
Most glass factories offer glass-blowing demonstrations, during which you can watch skilled artisans create colourful and covetable pieces.

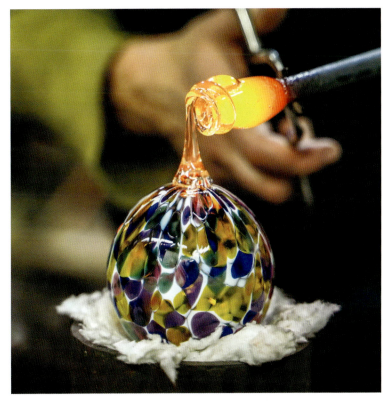

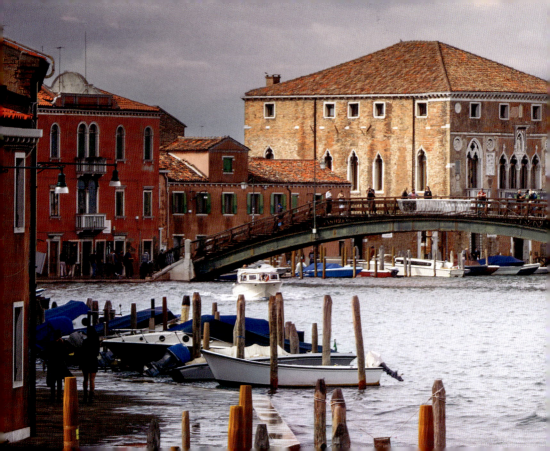

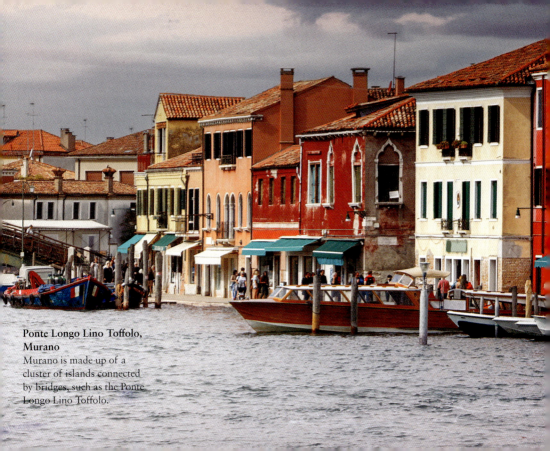

Ponte Longo Lino Toffolo, Murano
Murano is made up of a cluster of islands connected by bridges, such as the Ponte Longo Lino Toffolo.

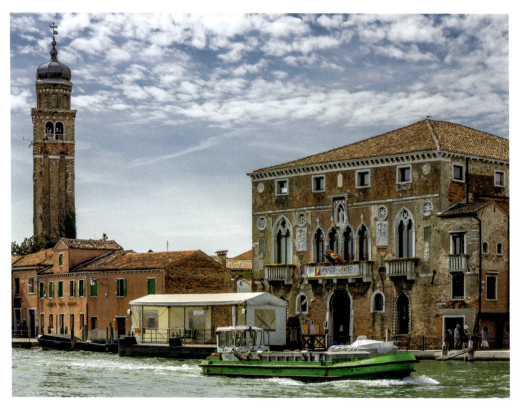

OPPOSITE:
Palazzo da Mula, Murano
Palazzo da Mula is one of the last remaining palazzos built on Murano in the 15th and 16th centuries for rich aristocrats.

RIGHT:
San Michele
Known as the 'Island of the Dead', San Michele was designated a cemetery island in the 19th century.

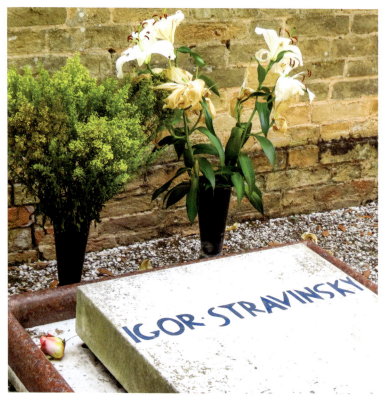

LEFT:

Gravestone, San Michele
Russian composer and conductor Igor Stravinsky is among the famous names buried on San Michele.

RIGHT:

Chiesa di San Michele in Isola, San Michele
The church on the island was built in white Istrian stone by Mauro Codussi and completed in 1469. The bold look was influential in the city, introducing a Renaissance style to Venetian architecture.

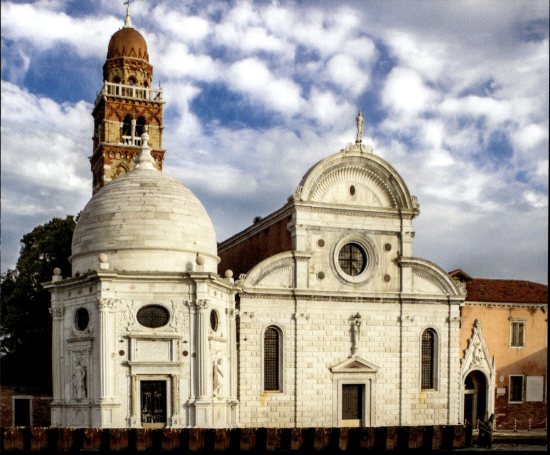

Defence system in the Venetian Lagoon
Protecting the city from flooding due to high tides is the MOSE System – a new-generation flood prevention system made of mobile gates. It is installed on the sea floor at the Lido, Malamocco and Chioggia inlets – the entry points where the tide spreads from the Adriatic sea into the Lagoon.

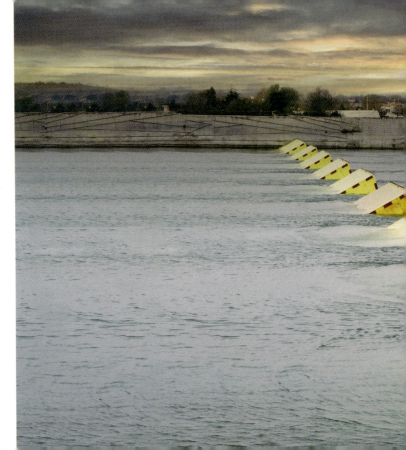

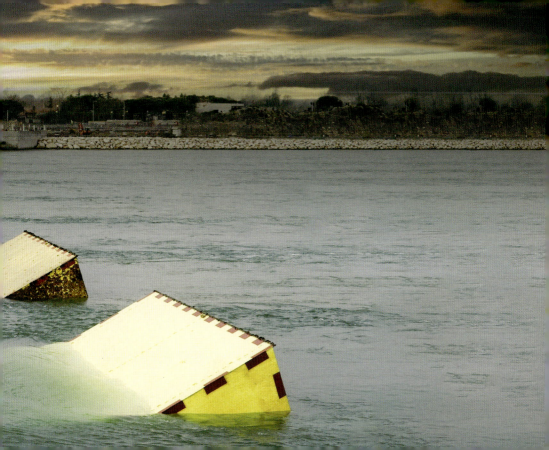

Picture Credits

Alamy: 8 (RealyEasyStar), 10 (Alberto Masnovo), 11 (lowefoto), 12 (Joana Kruse), 13 (Hemis), 14/15 (Peter Barritt), 16/17 (Image Professionals GmbH), 19 (Iain Masterton), 20 (Reda &Co srl), 24/25 (TravelScapes), 26/27 (Steve Tulley), 30 (jacky chapman), 32 (Juergen Ritterbach), 37 (Bailey-Cooper Photography), 38/39 (jacky chapman), 44 (richard sowersby), 45 (Julian Money-Kyrle), 46/47 (Julian Money-Kyrle), 48 (Juergen Ritterbach), 54 (Matthias Scholz), 57 (Frederic Reglain), 58/59 (Hercules Milas), 60 (AlexMastro), 62 (Neil Setchfield), 63 (Jason Knott), 72 (Image Professionals GmbH), 73 (TravelScapes), 74/75 (Panama), 84 (AGF Srl), 85 (Peter W. Fischer), 86/87 (ruelleruelle), 106 (pictureproject), 121 (Reda &Co srl), 134 (Matthias Scholz), 135 (Juergen Ritterbach), 144/145 (imageBroker.com GmbH), 148 (Juergen Ritterbach), 149 (AGF Srl), 154/155 (Roman Krykh), 156 (adam eastland), 157 (Hemis), 158/159 (Newcastle ps), 161 (peter.forsberg), 162 (Reda &Co srl), 163 (Clearview), 164/165 (Cephas Picture Library), 170 (Simona Abbondio), 171 (suesiyzer), 172 (Ben Pipe), 173 (Piere Bonbon), 181 (George Oze), 186 (Universal Images Group North America LLC), 187 (Image Professionals GmbH), 196 (imageBROKER.com GmbH), 200 (jackie ellis), 204 (Malcolm Park), 205 (Panther Media GmbH), 206/207 (Ingus Kruklitis), 208 (David Kilpatrick), 209 (Image Professionals GmbH), 210/211 (imageBroker.com GmbH), 212 (John Kellerman)

Creative Commons Attribution-Share Alike 2.0 Generic license: 176 (JumpInVenice.com)

Creative Commons Attribution-Share Alike 4.0 International license: 174/175 (Didier Descouens), 177 & 179 (Didier Descouens)

Dreamstime: 6 (Eduardo Andrade), 28/29 (Lofik), 36 (Sedmak), 40/41 (Jlindsay), 49 (Crisfotolux), 50 (Tanaonte), 51 (Mychadre77), 55 (Mistervlad), 56 (Jwendybaker), 61 (Karaul), 64/65 (Oksanasaman), 66 (Katrinshine), 68/69 (Raluca Lungociu), 88 (Igor Serdyukov), 92 (Andrey Maslakov), 96 (Alberto Masnovo), 98/99 (1tommas), 103 (Scaliger), 107 (Viacheslav Lopatin), 108 (Msalena), 116/117 (Donyanedomam), 120 (Office50633), 128/129 (Luckyphotographer), 130/131 (imagoDens), 136 (Karaul), 138 (Dietmar Rauscher), 139 (Sedmak), 140/141 (Karaul), 142 (ViliamM), 146 (Shawnwil), 150 (Photogolfer), 151 (Karaul), 153 (Mistervlad), 166 (Leklek73), 178 (Igercelman), 190 (Njarvis5), 191 (Boarding1now), 192 (Catalby), 194 (Lledospain), 195 (Momo11353), 197 (Seregalsv), 213 (Ivanderbiesen), 216/217 (Jarcosa), 218 (Marcoviaggi), 221 (Blitzkoenig)

Shutterstock: 7 (Tomas Marek), 18 (scimmery), 21 (Lois GoBe), 22 (Henryk Sadura), 23 (Isogood patrick), 33 (Lois GoBe), 34 (Sean Pavone), 35 (Cristi Croitoru), 42/43 (duchy), 52 (Wirestock Creators), 67 (Werner Spremberg), 70/71 (SvetlanaSF), 76 (Sergiy Palamarchuk), 77 (Fotopogledi), 78 (Dmitri Ometsinsky), 79 (Perekotypole), 80/81 (Catarina Belova), 82/83 (DaLiu), 90/91 (Matej Kastelic), 93 (Stefano Politi Markovina), 94 (Birger Niss), 95 (Oleg Senkov), 97 (Yurina Photo), 100/101 (Carolina2009), 102 (Alla Iatsun), 104/105 (Viacheslav Lopatin), 109 (chrisdorney), 110 (silverfox999), 111 (maziarz), 112/113 (Vepix), 114 (BGStock72), 115 (Viacheslav Lopatin), 118/119 (travelview), 122/123 (RudiErnst), 124/125 (Sean Pavone), 126 (Tanja G), 127 (pavel068), 132 (Lee Yiu Tung), 133 (Zakrevskyy Andrew), 143 (AlexandraFar), 147 (Florin Cnejevici), 152 (Rachelle Photography), 160 (calix), 167 (Leonid Radashkovsky), 168 (Marco Rubino), 180 (Vepix), 182/184 (lapas77), 185 (Cristi Croitoru), 188/189 (giocalde), 198/199 (cheyennezj), 201 (Iryna Budanova), 202/203 (chettarin), 214 (Aerial Film Studio), 215 (Stefan Malloch), 219 (Boumen Japet), 220 (Arndale), 222/223 (Zaltrona)